The Joys and Sorrows of Recent American Art

4.

PAUL JENKINS

Phenomena Point Swing and Flank

THE JOYS AND SORROWS OF RECENT AMERICAN ART

The DeYoung Lectures in Higher Education at Illinois State University, 1966

by Allen S. Weller

UNIVERSITY OF ILLINOIS PRESS URBANA CHICAGO LONDON 1968

Second printing, 1970

© 1968 by the Board of Trustees of the University of Illinois. Manufactured in the United States of America. Library of Congress Catalog Card No. 68–21666.

Cloth: 252 72689 8
Paper: 252 72447 X

FOR R. F. W.

Foreword

In 1966 I was asked to deliver the annual DeYoung Lectures in Higher Education at Illinois State University. This lecture series, founded in 1961 as a memorial to Mrs. Marion DeYoung, grew from the desire of a group of local religious foundations and student organizations to contribute to the intellectual life of the campus. Each year a lecturer is asked to speak from the perspective of his field to matters of general concern to the academic community. It was my good fortune to be asked to give the sixth annual lecture series, and I welcomed the opportunity of clarifying certain of my own ideas about some of the meanings (both overt and implied) of recent American art and about its relationship to other aspects of our time and place. I did not want to consider only the work of the last two or three years; I hoped to place the accomplishments and aims of young artists in a larger framework and thus felt it necessary to devote some attention to a group of productive and important older artists. Things move so swiftly in this field today that I am afraid some of my remarks already sound old-fashioned!

Certainly I could not have had a more interesting and stimulating environment for the period of the lectureship. The three formal lectures were surrounded by meetings and informal discussions with faculty members and students. Obviously one of the aims of the program is to remove the specialist from his own limited surroundings, and this was happily accomplished during the days I spent in Normal. I am particularly grateful to Professor Earl A. Reitan of the Department of History, who, as Chairman of the DeYoung Lecture Committee, extended the invitation which led to the lectureship; to Professor Perry Ragouzis of the

Department of Art (now of Colorado State University), who succeeded him and was my gracious host in Normal; to Professor F. Louis Hoover, Head of the Department of Art; to Professor Harold R. Phelps, Director of the Division of Special Education, who released the text for publication by the University of Illinois Press; and to President Robert G. Bone who was kind enough to allow me to use his office while I was on the campus.

The lectures were, of course, copiously illustrated with slides—many more than are included as illustrations in this book. The text consequently suffers in that certain points that I tried to make in the lectures have either disappeared or been much reduced in the printed form, and because I often paused (as any lecturer is bound to do when he has a captive audience in a darkened room) to expand on specific works which are mentioned only briefly here. But I hope that something of the pleasure I took in talking about a subject that is not easy to put into perspective and of the sympathetic interest which the discussion seemed to arouse, may survive in book form.

I am deeply indebted to the museums, the collectors, the artists, and the dealers who responded generously to my insistent and numerous requests for photographs and information. The names of all of them are included in the List of Illustrations. The correspondence I carried on with many of them as the text was prepared for publication was certainly one of the joys I encountered; as a matter of fact I can think of no personal sorrows in connection with the entire experience. I am particularly indebted to Mrs. Gay Menges of the University of Illinois Press for her expert help in preparing the manuscript for publication.

A. S. W.

Contents

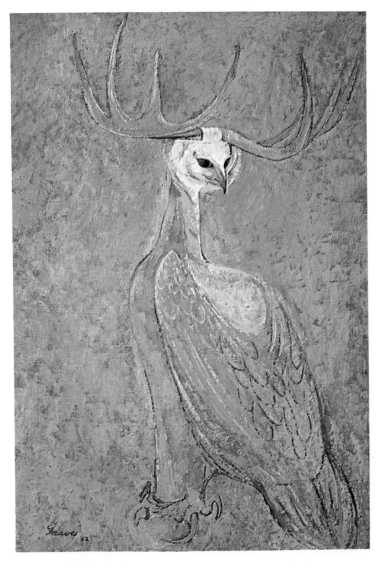

MORRIS GRAVES *Guardian*

1 Signs and Symbols

One of the many paradoxes of contemporary art is that while some aspects of artistic creation seem to proliferate at an ever increasing tempo, the deliberate obscurity of that art is also increasing. A peculiarly private kind of symbolism, an exploitation of uniquely individualistic expression, is the quality of much of the work by the strongest creative spirits of our times. This finds its outward manifestation in ways both overt and inferred.

The whole issue is confused by the fact that such highly personal forms of expression have become a language that in many ways is completely acceptable to a great many people. We welcome the mysterious, the unclear. The uncertainty we feel about all aspects of our world situation seems to find its counterpart in the deliberate pleasure we take in work that itself seems to be unresolved. More and more we are engrossed with the process of becoming rather than with the end product, the action that is finished and complete. Our interest in the movement of culture makes it increasingly difficult for us to see any specific work—whether it be a work of art or any other kind of activity—as a completely independent and self-sufficient thing. We are so conditioned that we automatically reconstruct the actions that must have led up to the act we are contemplating, and we speculate about what its effect will be on the future. It is almost impossible for us to live completely and richly in the present. The individual work of art more and more becomes a step, a stage in a development, rather than the definitive and final expression of a creative act.

Perhaps this explains why we now find the great products of mature civilizations less interesting than those suggesting the promise of future development. No more interesting history

of changing taste exists, for instance, than is seen in our attitude toward the work of so-called primitive or nonhistorical people. Such work (African or Oceanic) was once collected largely for anthropological or ethnographical reasons and was exhibited in museums specifically formed for such studies. Ever since the early years of the twentieth century, when the *fauves* in Paris discovered African sculpture and removed it from its ethnographical context, such work has been a prime source of contemporary influence and inspiration. In a similar way, the almost changeless artistic language of childhood, which long remained unseen, or at least was not thought about, suddenly in our times becomes a source of penetrating insight, not only from the point of view of style, but also as symbol. Although the layman probably often misjudges the aesthetic intention of African sculpture and often has highly romantic ideas about the role of the artist in the society that produced it, we feel an instinctive sympathy with an artistic language that seems more direct, more complete, than any the extreme diversity of background influences will allow us to produce today. The quality above everything else that attracts us so powerfully to such work is its ability to give us the reassuring feeling that the artist knew exactly what he wanted to do, that he did not have to search for a subject or a theme, that personal doubts and individual problems or eccentricities were dissipated in the understandable act of creation.

The child also knows precisely what he wants to say in a work of art and creates it without hesitation. But here is the (to us) added attraction of the first attempt, the excitement of a real beginning. How many mature artists have wished they could preserve or recapture the sublime boldness of expression we often see in children's drawings! Too often the mature sophisticated artist or critic confuses the fresh and self-generated art of childhood with technical crudity or incompetence and deliberately substitutes these. Just as it is impossible to reconstruct a style that has died a natural death (historical revivalism can produce excellent work, but it has never really recaptured the original character of the style it attempted to "revive"), so it is impossible for a mature artist to work in the style natural to childhood. Our

admiration of the two kinds of work mentioned here is understandable, and, in itself, healthy; the tragedy, which has almost unconsciously emerged from it, however, is that we have confused incompetence and crudity with freshness and directness. We must accept the fact that we are grown-up and that we live in a complex and sophisticated society. It is just as artificial for us to try to create nonhistorical or nonsocial works of art as it was for the nineteenth century to re-create Greco-Roman forms that were transposed into new materials or grafted onto new technological devices.

A striking characteristic of much contemporary American art is the influence the machine has had upon it. And this is surely easy to understand. The head-on collision between man and machine has presented our culture with one of its greatest problems and one of its greatest dilemmas. How are we to preserve those humanistic qualities that are the core of life and experience at a time when more and more of the activities that in earlier ages were the distinctive marks of human initiative are taken over by man's creation, the machine? The relationship between the artist and the machine has a number of different aspects.

In some cases the machine has been a direct threat to established artistic activities and has made obsolete entire important aspects of long artistic standing. For example, the whole documentary importance of art as a means of recording the appearance of events and people has largely disappeared. Historically, the first response of the artist to a new mechanical process that seems to move into territory he has previously occupied alone seems to be emulation. When, in the first half of the nineteenth century, the photographer seemed about to usurp the place occupied by the portrait painter, one of the first things painters did was to produce paintings as much like photographs as possible. The dreary quality of much "official" academic painting of the mid and late nineteenth century can certainly be attributed to the attempts of certain artists to compete with mechanical methods of recording visual impressions. The growing familiarity with black-and-white imagery in the nineteenth cen-

tury must have had an effect on total artistic processes. Many of the weak elements in the art of the period, like the loss of a feeling for basic internal structure and an excessive preoccupation with purely surface effects, may be the result of a greater and greater degree of photographic or mechanistic vision. Nor were these influences confined only to the academic artists. In a certain sense, the ultimate result of such new methods of recording visual phenomena was the development of impressionism and the whole characteristically nineteenth-century habit of divorcing visual impressions from thought—from mental processes—and consequently largely removing the symbolic quality which imagery for centuries had invariably had.

Although it is possible for a man to work in some degree like a machine and for the artist to produce works that look almost like photographs, many men either quickly tire of doing so or will never even attempt it. The aesthetic reaction to the machine was consequently twofold: an initial phase in which certain artists in effect turned themselves into machines and a later or parallel phase in which artists declared their humanism by deliberately doing exactly those things machines cannot (or should not) do. In a very real sense, the machine gave the artist a new freedom in that it removed from him the necessity of doing many things he had been called upon to do before. He consequently took more and more delight in acting unlike the machine. The machine is supposed to be functional, efficient, standardized, direct, orderly, manageable. Therefore, the artist will be involved in accidents, in the production of objects of no obvious use, in unusual and unexpected novelties, in highly personal and often deliberately obscure statements. All of this is a declaration of independence from the machine, an affirmation of the human being's refusal to be computerized. Many of the extravagant qualities of some contemporary art—the bizarre techniques, the inappropriate use of materials, the contempt for physical permanence—are simply a kind of last-ditch insistence on exploiting just those qualities that seem out of place in the theoretically technological society we have created.

Paradoxically, these actions have resulted in "big business." Such impulses and the works resulting from them have become important objects of commerce; dealers and collectors and museums feed upon them and show us that it is not only the artists who are deliberately revolting from the machine. We take a vicarious delight in showing that we have not turned into robots by participating in such activities. There is a second paradoxical element in the situation that is even stranger: the protest against the machine and the insistence upon a high degree of individualism has itself become standardized. It is one of the curiosities of contemporary American art that so much of it, at a time when at least theoretically it is completely free to do whatever it wants, falls into a relatively few rigidly defined categories. The standardization of the irresponsible seems to be behind a good deal of recent work. Joshua Taylor speaks of our times as one "when hysteria has become intellectually respectable, and reckless young artists try desperately to construct themselves an anarchist Bohemia within the safe structure of the Fulbright Program."[1] The mass production of goods of inferior quality seems to be a peculiarly American characteristic, and at times we may feel that precisely this has happened in the field of art.

While, understandably, a certain kind of artist deliberately turns his back on the machine and all that it stands for, it is at the same time a quality of artistic vision to see the beauty residing within the machine. Industrial designers are, of course, completely aware of the possibility and the necessity of combining beauty of design with proper functional performance, but the vision of the artist is directed primarily toward form alone. Often, in recent exhibitions, we have seen works that look to us like complex machines, whose purpose and function remain completely mysterious. The materials and the technology of machine tooling have been used for personal and expressive purposes. This is the opposite of the initial nineteenth-century artistic response to the machine by which the artist sought to duplicate the

[1] Joshua C. Taylor, review of B. S. Myers, *The German Expressionists, CAJ,* XVIII, 3 (Spring, 1959), 269.

results of machine action; in the machinelike art of today, it is not the results that count but rather the symbolic implications that may be expressed and developed.

Two possibilities immediately present themselves. The artist may take actual mechanisms and, by combining them in new ways, by isolating them from their intended relationships, make us see them in a totally new way. The artist has transformed them. Throughout history one of the primary activities of the artist has been the proclamation of existence for its own sake, the affirmation of being. At our moment in history it is understandable and appropriate that one of the major affirmations we can make is through the use of such material. The constructions of Richard Stankiewicz are examples of such transformations (1).[2] Wheels, chains, boilers, springs are given unexpected new life and character and seem to establish themselves symbolically as a new kind of expression. The individuality and unpredictable quality of the unique human being is fused with the products of the machine age.

The second method is seen in the constructions of Lee Bontecou (2). These vast forms, constructed of welded metals and canvas, do not use actual objects created for other (practical) use but are expressed in the language of the machine. There is an imposing and even ominous authority about these great forms. They seem to perform some important function that is hidden from us, and certainly the mysterious element that lies behind them is not the least of their potent qualities. Notice that in the work of both Stankiewicz and Bontecou the element of age is present. These objects are not new and shiny; they tend to have rusty, corroded surfaces or to simulate forms that bear the impress of use; they are worn; at times their strength is combined with a sense of exhaustion. The maturity, perhaps the antiquity, of the machine age finds in them its final expression. Recently a third, and presumably a final, stage in this development has been reached. The artist deliberately becomes himself as much of a machine as possible. The medium and the technique scrupulously avoid the sense of the artist's participation in the creative act.

[2] Numerals in parentheses refer to plates located in the last section.

The imagery is selected, not formed or invented, by the artist. Andy Warhol, who assaults us with multiple identical images, just as do the mass media of communication, presents an art that is an outgrowth of newspapers, films, and TV rather than of painting (3). His images are public property; they are presented baldly, without interpretation, and their symbolic value is created by the spectator rather than by their manufacturer.

The deliberately impersonal quality of certain aspects of recent art may certainly be attributed to the mechanistic side of our culture. The unmodulated color areas in many recent paintings, the avoidance of the brushstroke, the use of letters and numbers that seem to be mechanically transferred to canvas by stencil, are frequently seen. This is the influence of certain kinds of advertising art, of mass-produced and consequently impersonal imagery. A painting by Robert Indiana is related to signs and commercial symbols (4). With its ruler-straight edges, its compass-constructed circles, its simulated stenciled lettering, its flat colors, it accepts the visual language of familiar aspects of our period and places them in a new context.

A result of all this is that we inevitably see the machines and the machine-created forms surrounding us with new eyes. Objects created for purely functional purposes seem to acquire symbolic and expressive qualities. The artist not only uses and relies on his own vision, he forces us to revise our own. Anyone who is sensitive to this aspect of the art of our time will certainly be affected by it outside of the art gallery.

Another characteristic that meets us in a great many different ways is the violence inherent in much contemporary imagery. Ours is a violent age; we are involved in conflicts of every kind. These are both external and internal, and the history of our times sometimes makes us despair of their resolution. The elements of conflict are, I suppose, inherent in all acts of aesthetic creation. The work of art today is of necessity a highly individual creation (one of the few left in our kind of culture), and consequently compromise and mediation, which are group activities, can hardly find expression in the fields we are dealing with. There is first of all the struggle between idea and material that every

artist must face. There is the struggle between the artist and the public and the very real economic problem facing most young artists. These are internal matters. But the artist is inevitably sensitive to the conditions around him, and the social tensions of our times, the great problems of war and peace, must affect him profoundly. Small wonder that these qualities find both physical and symbolic expression in his work.

There is violence of subject matter, and there is violence of style. By the first I do not mean simply the depiction of scenes or representations of violent acts—which, indeed, are not often encountered at the present time—but rather the violent way in which physical forms, which we perceive visually, are distorted, abused, exaggerated, or coerced. Nature is transformed into images of distress and pain. In the realm of form, as distinct from subject, the material with which the artist works may seem to have resisted his will, to have actually put up its own struggle. Some contemporary works of art make us think of battlefields, where artist and material are working almost independently of each other. Some of the excitement of contemporary art may lie in the fact that often we are not sure who is winning this conflict. No idea is encountered more frequently in the statements that it is now the custom for artists to produce about their work than one stressing the fact that the artist and his work are functioning almost independently. Adolph Gottlieb, for instance, once wrote about a painting, "I had quite a struggle with this picture. . . . I was forced to modify the original conception. . . . In the end, when it was perfectly clear what I had been searching for, the painting practically finished itself."[3] This is the language one would apply to an external battle, not to the resolution of an internal idea. Contemporary art is often very aggressive, not only to the spectator, but also to its creator.

Finally, abstract forms, as distinct from subject matter and material, may and often do express violence. The explosive quality of shapes, the tearing and rending of mass, the consuming

[3] *Contemporary American Painting* (Urbana: University of Illinois Press, 1951), p. 182.

action of a highly aggressive kind of space, are frequently encountered.

The terrifying pictures of women Willem De Kooning painted in the 1950's are images of violence (5). The physical forms are gross and predatory, with an emphasis on aggressive sexuality. Normal physical relationships have been violated, and the image has been expressed in material forms that are striking at each other painfully. A physical tug-of-war is being waged within the very fabric of the painting. It would not have been difficult for De Kooning to remove those elements that allow us to identify the image as a vast seated female, and if he had done so, the struggle would have been just as clear. This, and its companion paintings, was an important event in reintroducing the violence of imagery as well as the violence of form into the language of abstract expressionism.

On the other hand, the violence of Roy Lichtenstein is expressed purely in theme (6). The artist deliberately avoids the material struggle that De Kooning exploits so powerfully; the strange effect of these works resides partly in the illogical contrast of violent theme and coldly impersonal, mechanistic surface and deliberately insensitive color. The visual language of the comic strip has been blown up to monumental scale. Whereas De Kooning's violence is existential, Lichtenstein's is symbolic. A purely abstract work like a painting by Jack Youngerman is a record of physical forms undergoing a violent reshaping under explosive conditions (7). There is a sense of tearing, of breaking. We seem to be in the midst of the painful emergence of a new kind of physical order about to be created from the dissolution of older relationships.

The imagery of the contemporary artist often evokes the idea of death, of decay, of destruction. It may be the physical death of living beings, either man or animal, or it may be the breakup of the material fabric of organic living matter that is suggested. In a culture like ours, which has not yet achieved a satisfactory and satisfying balance between man and the man-made environment he has created for himself, a mood of despair

is frequent. And there is a death of the spirit as well as a death of the body, which also finds its expression in the art of our times. Indeed, certain aspects of the mechanistic expressions of contemporary aesthetics may, perhaps unconsciously, be the result of such a spiritual climate.

Another of the paradoxes of contemporary culture is that as we invent new forms and new materials and as we strike out into totally new fields of explorations, we are weighed down with a sense of the past. It is impossible for us to live completely and simply in the present. The sense of evolution makes us inevitably see contemporary happenings as the result of things that happened in the past; new births emerge out of old deaths. New life springs into being from the rich decay of what has passed away.

How often do we encounter contemporary works of art that look as if they reflected the action of time! Corroded surfaces, scarred and injured materials, objects of an apparently archaeological antiquity, forms that look as if they had been excavated or dredged up from the depths of the sea, are fascinating to us. This may be partly the result of our intense interest in history, our almost obsessive sense of the past, that has led us to know whole great periods of art only in ruined or semiruined condition. Our museums are full of the fragments of the past, and it is doubtful that we would today really "like" many of the things we now admire were we to see them in all the freshness and richness of their original condition. Certainly the slick, colored surfaces of Greek sculpture and the gleaming brilliance of Renaissance panels as they appeared in their original condition might appear positively offensive to the eyes of the twentieth century. We now seem to shy away from the perfected statements of artistic maturity and instead feel a peculiar sympathy with fragments and ruins on the one hand, and with the statements of naive or primitive or childlike artists or periods on the other.

Sometimes the animal is a surrogate for man in the dance of death the artist invokes. While Rico Lebrun found the extermination centers of Nazi Germany a compelling and obsessive theme and was also engrossed with the theme of the crucifixion, he perhaps never presented the idea of physical death more power-

fully than in the vast images of great foreshortened dying steers (8). Indeed, there is a peculiar pathos about the death of an animal which is, in a sense, more final than is the death of a man. The unconscious and incomprehensible are here undisturbed by any glimmering conception of a life beyond death. As a symbolic form, the death of an animal is an absolute. The sacrificial animals of Jack Zajac seem to hark back to very ancient impulses in our being (9). These works carry us far away from lucid and rational responses in ordinary existence and bring back to the surface emotions of age-old quality.

We often encounter images that express the finality of physical death—a limiting of horizons, a loss of individuality, the exposure of that which has long been concealed, the reduction of organic existence to its dissolving essences. All of these symbolic statements are highly personal, and it is not impossible that we are reading meanings into them that were not always specifically considered by the individual artists who created them. But the artist is not always the one who knows most about the meaning of his work. More and more frequently the contemporary artist seems to be an instrument, a medium, a device for the transmission of forms and forces outside of himself, rather than the architect of self-established and self-selected themes.

Sometimes we feel that the contemporary artist is playing a guessing game with his spectators. This is probably not conscious, but more and more frequently aesthetic expression tends to develop a highly personal kind of symbolism that is not the result of widely held social tendencies but rather springs from within the most intimate and unique qualities of the individual creative personality. The individual in twentieth-century art is frequently hidden or disguised or masked. It is illuminating to note the way in which certain motifs suddenly become popular and seem to answer a particular need the generating group feels.

One such motif is the mask. It appears either as an actual mask with which a figure covers up the face and which seems in itself to be more important, to have more character, than the actual head; or it can be expressed by giving a masklike quality to the face. A mask is not the same thing as a portrait. It suggests

that a deception is being carried on, that a quality or character alien to the primal being is projected to the rest of the world. As is the case with many other symbolic elements in contemporary art, I am not suggesting that the artist has always deliberately formulated such ideas in objective terms but that the total situation in which he finds himself makes such forms sympathetic and full of meaning for him.

Abraham Rattner's *Figure and Mask* is a case in point (10). Is it really a mask this luminous being holds in his hand? Or is it the head itself, removed from the body that should support it? Certainly the actual head seems rudimentary, inexpressive, lacking the quality of evocation, as compared with the form the figure carries with a ritualistic intensity and dignity. It is not possible to attach specific "meanings" to such a painting, to give an "interpretation" of it, but it suggests a whole range of associations; and the fact that some of these are decidedly mysterious is part of the artist's intention.

The appearance of the actual mask in contemporary art is in itself a significant fact. Originally, the mask was always an adjunct to another art form: an object worn by dancers in Africa, part of the total costume of actors in ancient Greece and Japan. The mask was always seen in relationship with an actual living protagonist, transforming him into a new being, endowing him with different and more important qualities than were his as a mere individual. Such masks were stage properties, and I expect that they were treated as such and were not ordinarily seen except during an actual production or performance.

In the Renaissance death masks were made purely to record the features of specific individuals. They were not themselves thought of as works of art but may have been used as source materials in the production of portraits. I do not recall that the mask as an independent art form, divorced from practical relationships with public performance or with fact-finding, existed until our own times. I think there are two reasons for this.

In the first place, the mask is the perfect expression of the isolation of the individual. Such an example as William Zorach's *Contemplation* allows for a concentration upon the content of

the work that would be impossible in any other way (11). Time and place are nonexistent; male and female are indistinguishable. This is the essence of a human being, lost to all surrounding influences, an abstract idea given concrete form.

Harold Tovish's *The Blind Man* is another kind of mask (12). This has all of the qualities to which I called attention in the earlier example, but, in addition, it suggests something concealed. The smooth, subtle irregularity of the surface has a strangely inhuman quality; the empty eye sockets suggest the possibility of living sight emerging through them. The closed eyelids of Zorach's mask direct everything inward; the empty sockets of Tovish's make us look through the mask into something not present but suggested.

Some of the most completely "humanized" works produced in our times do not represent the human being at all. Indeed, a good case could be made to the effect that the image of the human being is an inhibiting factor in the most complete and intense expression of those qualities we think of as humanistic. Image-making can all too easily turn into a purely materialistic reproductive activity. It is not man's body, nor his physical functions, which distinguishes him most completely from other aspects of the world of nature: indeed, it is much easier for us today to think of ourselves as an organic part of this world than was the case before the structure of nature had been so intensively investigated. So we need not necessarily expect to identify individual human beings in works of art which are yet about human beings. The mere identification of the specific individual becomes less and less important in a society like ours. This may be a matter for regret, and romanticists will deplore it, but it is something forced upon us in a great variety of ways from all sides.

One result has been the emergence of works of art that are about human beings who aren't there. Sometimes we feel that certain recent works of art are like tracks in a forest; they let us know that something has passed by, and they may enable us to reconstruct exactly what this something was like, but we can never catch up with it, and we can consequently never precisely

identify it. On the most obviously material plane, such a work as Claes Oldenburg's *Shirt on Chair with Wallet and Other Objects* is such an assemblage of indications (13). All of these highly personal objects have been thoughtlessly dumped on an actual piece of furniture; they tell us everything—and nothing—about the person who dumped them. So far as I know, no earlier period in history would have produced and exhibited such a conglomeration of objects, apparently without any literary sort of symbolic significance. All that it seems to say is: a human being was here. This is what he left behind.

Is it art? Yes, because we accept it as art. I do not agree with those critics who divide things between "art" and "anti-art." We can have our own opinion about good art and bad art, about success and failure, but I think it is much more important to try to form some valid measure of these qualities than it is simply to reject things with the cry "It isn't art!" I am also familiar with the argument that the artist should transcend the characteristics of our age that have made it impossible for him to produce works that look like the admired masterpieces of the past. But transcending one's period is not just an individual matter.

Oldenburg's work is bare, raw; it exists purely within itself. Although every object is intimately associated with someone who has left, it is prosaically and deliberately lacking in any kind of psychological relationships or suggestions. At the opposite end of the scale is Ibram Lassaw's *Zodiac House* (14). This, too, is an object that may be interpreted as something left behind, but in this case the unexpected and unidentifiable forms suggest many levels of possible meanings and relationships. It is like a deserted habitation; surely the straight edges, the rectangular openings, were made long ago by some unknown race of man. There is an elegant disdain, a sense of exclusive and aristocratic withdrawal, in the way this strange, empty habitation raises itself above the limitless earth surface on slender supports. Above, the world of organic nature, of uninhibited growth, asserts itself in the delicate forms that reach out and join one another. It is all old, weathered, long abandoned. I am aware that I am giving a romantic interpretation to a work that could also be considered from a

purely formal point of view, but the work allows me to do this even if the artist does not. Lassaw's work does not evoke a specific individual personality, but it establishes a whole environment that was once occupied but from which something has fled.

Sometimes the artist wants to remove not only the actual physical presence of the being or beings he deals with but also himself. A large group of contemporary artists finds the strong expression of the artist's own personality an irrelevant vulgarity, old-fashioned and out of keeping with the increasingly technological world in which we live. Ruler and masking tape, spray gun and cut paper increasingly take the place of brushstroke and impasto. Unmodulated surfaces, undifferentiated colors, cool, impersonal solutions to sharply defined problems are often encountered. The influence of architectural plans, of blueprints, of engineering drawings is increasingly seen.

An untitled painting by Arakawa makes a most interesting comparison with Oldenburg's *Chair* (15). Here, instead of actual objects, are traces, shadows of some kind of human activity. Intimate objects (combs, coat hangers), footprints, the vagrant pattern of an abandoned piece of string are suggested with a curiously luminous impersonality. The repetition of the principal images gives a symbolic sense of movement, which almost brings to mind the work of the Italian futurists but now with a studied removal of the artist's own handwriting. What we have is not only a series of traces of some unexplained human actions but at the same time a discreet suggestion of an artist who has deliberately concealed himself.

The sense of being alone in a crowd of people is a theme that frequently occurs in contemporary art. Here the artist isolates the individual, not by reducing him to a mask or disguising him or allowing him to express himself only indirectly but by cutting him off spiritually or emotionally from surroundings that in other circumstances (one now hesitates to call them normal!) would sustain him and flow into the individual. There is no doubt that the artist today often feels a sense of alienation from the dominant activities of our society, and consequently this theme may have peculiarly personal connotations for him.

The motif is expressed very literally by Ben Shahn in *It's No Use to Do Anymore* (16). The rootless anonymity of the setting, which includes no suggestion of a specific time or place, the strangely floating quality of the hospital bed upon which an unidentified figure lies, one supposes, *in extremis;* the arbitrary cutting off of the figures of the spectators so that there is no firm ground plane upon which they can plant themselves, create a disturbing ambiguity in the entire scene. Is it reality or illusion—or a kind of reality that differs from the material realization of physical experience? Note, too, how frequently in contemporary image-making we see the figure from the back, or from an angle that makes it impossible for us to see precisely those features by which we ordinarily identify the specific individual.

The figure need not be actually surrounded by other figures, or observed by other figures (as in Shahn's painting), in order to suggest aloneness in a crowded society. A whole setting may be evoked by a few material objects. And here we note a most interesting development: the introduction of raw actuality into art, the mingling of the formal creation of the artist with the "real" objects of everyday life. The incorporation of an actual table, chair, and window frame into George Segal's *Seated Man at Table* brings up a number of problems (17). The figure itself is frankly a cast of an actual body. This is a new kind of artistic transformation. In the past, the artist grasped the experience of nature, of his physical surroundings, visually and tactually, and created a series of symbols by which he revealed his comprehension of such experiences. Segal has taken the actual stuff of existence and with scarcely any transformation at all has isolated it and made us see it with an intensity that is different in kind from that which would be aroused by the physical body itself, or by the ordinary objects associated with it should we see them in their original condition. The loneliness of the figure is emphasized because it becomes simply an object, a thing, on the same level as the chair and the table. It is without overtones, without associations, it is more like a mummy than a piece of sculpture in the historic sense. This development is related to the kind of artistic thinking that led to the discovery of the artistic possibili-

ties of the *objet trouvée* early in the twentieth century but with one very big difference: the found objects have not been transfigured or changed into something new and different but are simply presented to us for what they are. We have usually thought of highly representational art as being, in some degree, "literary," as relying upon subject matter as distinct from or separated from form. But here is a new kind of realism, peculiarly characteristic of our moment in history, that rigidly excludes associations and suggestions and relationships. It shows us that it is now quite possible to be almost completely impersonal and completely specific at the same time.

A much more obvious case is seen in George Tooker's *Government Bureau* (18). Here is a whole repertoire of timely motifs: figures seen from the back, so that their faces are concealed; the regular repetition of shapes and forms in perspective arrangements that suggest an endless proliferation of mechanical elements; the mask motif in the isolated parts of the faces that peer at us from behind impenetrable walls of opaque glass; the smooth impersonality of surface that seems to remove the artist from direct personal contact with the spectator. In a composition crowded with figures, suggestive of busy activities, full of the possibilities of human contacts and relationships, all action has been arrested, all contacts have been cut apart. The figures in the painting, the artist, and the spectator—all are disassociated one from another.

Loneliness, the tracks or traces rather than the substance of humanity, the isolation of the mask, all suggest a basic loss of identity, a fragmentation of the individual. We have already noted the motif of the figure that seems to conceal precisely those physical characteristics that would ordinarily lead to identification, and there are other evidences in recent work that point in the same direction. Some have already been mentioned in other connections, but the theme of loss of identity emerges in many forms.

Sometimes it becomes a kind of romanticism, a deliberate obscuring of definition for purposes of suggestion. Figures may be lost in a luminous mist. They become part of a humanized

rhythm, but they never detach themselves from an enveloping atmosphere that blots out all specific individuality. In some works there is a physical kind of sympathetic unity binding together figures, movement, and feeling. Different in kind are the faceless figures of Nathan Oliveira (19). Here it is not so much the merging of man with his environment that has led to loss of identity as it is emphasis upon inner states, inner tensions and sensations, which now take the place of all external forms. Oliveira's figures seem to present us with emotions stripped of their usual physical envelope. They are like exposed nerves. They present sensations; they do not represent forms. Such a style is a perilous experiment; it has the possibility of creating works of penetrating power, but it can also, and all too often in the incompetent hands of imitators, become a hopeless substitute for clear thinking and positive accomplishment.

From the point of view of imagery, the enormous impulse our period has felt toward the nonrepresentational can also be considered as a loss of identity, though paradoxically it may also be the strongest possible way in which the unique personality of the creator can be expressed. What kind of individuality are we talking about? The individuality of something *outside* of the artist, or the individuality residing within the deepest core of the creative personality? It may be that only by completely freeing himself from external reality can the artist be completely himself. But again (as in the case of Oliveira's internalized figures) a theoretical source of effective strength may all too often become a refuge for indecision and weakness.

There are many recent works in which the artist seems to have deliberately limited himself in such a way that it is hard to achieve anything like complete expression of personality. Limitations of materials and methods, limitations of motifs, avoidance of personal expression—all of these are a matter of choice. One can hardly criticize a work for not accomplishing something it never attempted; one's criticism must rather reach out to the more basic concept, to the original intent. Is it poverty or discipline that has led to such restricted expressions?

Few critics are willing to face the issue, and perhaps they

cannot. We will probably need the perspective of time in order to make such distinctions. It is easy to "explain" contemporary art on the basis of the social and emotional conditions of our times, but explanation is not evaluation. What are we to do, for instance, with such a work as Paul Brach's *Riddle No. 1* (20)? A single color of slightly different intensities, two basic and elemental shapes, rectangle and circle—this is all, unless we choose to read into it suggestions or symbols of space. It is not too difficult to yield oneself up to such a work in a kind of hypnotic trance, and it may indeed have a completely legitimate purpose in forcing us to concentrate upon a kind of singularly pure experience, which allows of no distractions and which seems to transcend the normal experiences of local time and place. But it certainly moves far away from the humanistic center of almost all forms of art productions of the past. I use it here as an example of one kind of loss of identity, although I realize that it is not impossible to give it an almost opposite interpretation.

One of our contemporary obsessions is the internal structure of things. On the whole, we are much more interested in what happens inside, beneath the surface, than we are in what reveals itself upon the exterior. In many ways, this aspect of matter seems much more "realistic" to us than does the superficiality of externals. Our exploration of structure from the scientific point of view has led us to see reality in terms unrelated to the visual impressions of normal sight and to concentrate much more upon hidden elements in physical experience. Our heightened awareness of the physical reactions to spiritual and psychical states is related to the overwhelming sense of the interior that is part of our characteristic language today.

Here one feels like going back over thirty years to a painting that became a classic in defining this motif. Picasso's "Girl Before a Mirror" in The Museum of Modern Art, New York, is a remarkable visual symbol of the way in which the artist's mind explores the idea of physical structure from divergent points of view. We see the face (perhaps it would be better to say we *think* *of* the face) from the front and in profile. The globular forms in and of the body express the visceral structure of the total organ-

19

ism, which we seem to see from inside and outside, from above and below, and then still again in inverted form in a mirror reflection. Picasso's painting is the record of a mind that has contemplated a humanistic physical theme from many different aspects, no one of which is of more commanding importance than another.

In the full generation since Picasso painted his picture, this sense of the interior has remained with us more and more strongly. Here it is seen in Theodore Roszak's *Explorer No. 2;* a human cranium has been delicately laid open, dissected if you will, thus exposing to our gaze the precise nervous structures within (21). There is something at once elegant and painful about this curious exploration of the physical stuff of existence.

There are other ways in which our probing, both mental and actual, of the hidden core of reality affects artistic form and structure. Frequently we encounter works in which a kind of centrifugal energy places elements we would expect to find physically centered in a composition at the edges of the area involved. There is a characteristically explosive quality about such a purely nonobjective painting as Sam Francis' *Blue Balls,* with its unexpectedly empty center (22). We are used to a classical kind of composition in which the major forms of the design are centered, with appropriate and adequate blank areas surrounding them, generally with an extra amount of it at the base in order to compensate for our instinctive reaction to the sense of gravity. But Sam Francis upsets all of this: these blue forms have been thrown out of their central equilibrium; they have been cleared away, and room is made for a new kind of concentration—upon the emptiness of space itself, which now becomes not a support or a sustaining element but a focal theme.

Nothing indicates more certainly some of the most basic changes in contemporary artistic thinking than our attitude toward space and the increasingly important part it plays in design. For hundreds of years space was predominantly something that simply wasn't there. People thought in terms of mass and largely identified the concept of reality with mass. Anything you could touch or lift or walk around was "real"; everything else was

simply a kind of nothingness. When space was a conscious element in artistic design, as it was in Baroque art or even in such thinking as led to the location of classic temples, it was an infinite and indeterminate area into which mass obtruded, which formed a background or a setting for it. It was fundamentally unreal, passive.

Today the situation has almost diametrically changed. Space is the most real, the most positive, the most tangible element in our thinking; indeed, it is the great contemporary obsession. We move around in it at rates never dreamed of in the past; we explore its outer reaches in previously unimaginable ways; we are devoting our skills, our inventions, our imaginations, and our fortunes to its conquest in a totally new way. Space is the most aggressive part of the material with which the artist works today. It has consumed mass in many cases; it has turned many forms inside out; it has radically changed the whole concept of architecture and sculpture. More and more the mass elements in design become simply thin cutting edges between areas of active space.

Joseph Goto's *Organic Form No. 1* could never have been created as a work of art in any other climate, though forms related to it might have emerged for specific functional engineering purposes in another context (23). In a way it makes us think of the great structures that march across whole landscapes carrying high-tension wires. It has no front or sides or back but exists in unlimited, total space. Its delicate pointed members probe the surrounding space, which moves through its skeletal form. Though totally nonrepresentational in any specific sense, it is disturbingly humanistic at the same time. The general proportions and its divisions suggest a strange, unfamiliar kind of organic being, not totally unrelated to mankind. In material, technique, and construction it relates far more to the technology of the machine age than it does to the conventional sculptural techniques of the past.

The aggressive quality of contemporary space is the principal theme of the sculptor Alberto Giacometti, whose emaciated figures seem to be trying to escape from its encompassing power. Indeed, Giacometti's work can be arranged in almost exact

chronological order as we see his humanistic forms reduced to thinner and thinner dimensions by the consuming activities of space. Mass seems to have been literally eaten up by a voracious and dangerous element. The huge scale of the feet (still in contact with mother earth) suggest that the figure was once of much larger scale but that what we see is all that is left after space has devoured it. There is something hunted, desperate, about these anonymous, emaciated, but intensely nervous and sensitive beings. Giacometti's powerful and aggressive space sometimes leaves nothing but the merest fragment or trace of original completeness: a detached arm, an outspread hand, a footprint. The unlimited things beyond the control of the artist are really the most significant elements in such a work. It marks an almost complete reversal of most earlier artistic methods.

In the field of painting we see such works as the great floating films of pure disembodied color that Mark Rothko reveals to us (24). They are not flat planes; they do not present us with shapes in perspective; their boundaries trail off into infinity. We seem to lose ourselves in great distances. We do not get the effect of looking up or looking down or looking into: instead, we are ourselves engulfed, surrounded by symbolic space of a peculiarly powerful kind. As in the case of Giacometti, something which is not actually part of the physical fabric of the work of art becomes the most positive element in determining its unique character.

Many of the works we have looked at suggest to us another basic characteristic of much recent artistic composition: the twentieth-century artist is a prolific inventor of new kinds of life, of new organic forms. He is no longer satisfied to deal only with the life-forms he is familiar with in actual experience, but he calls into being organisms having all of the dynamic logic of the animal and plant forms nature has provided us but which are his own. He is truly creative, truly a giver of life. This is the greatest gift of the artist. In some cases the artist combines natural forms in unexpected ways. The great antlered bird in Morris Graves's *Guardian* is a form of magistral power—mysterious, authoritative. Here a new symbolic form has been created that is more

than the sum of its parts (25). On the other hand, Seymour Lipton's *Knight* is an intensely energetic being of a completely unidentifiable type (26). It has some of the characteristics of crustacean forms, with its sharply pointed spiny exterior, its softer and more complex organic interior. It is certainly in no sense a mechanistic form but a new kind of life itself. One of the most interesting creators of a new artistic biology was William Baziotes (27). His strangely pliant beings move softly about in a fluid life-giving space, often sending forth delicate tendrils or antennae which curiously explore their surroundings. There seem to be nuclei, ganglia, an organic focus within the embracing form. The color often has a tender, unfinished, growing, change-able quality. The mood is lyric, romantic. This is the creation of new life rather than the enhancement of life as we already know it or recognize it.

Jack Squier's *Blind Animal* sums up many of these preoccu-pations (28). Here is a cell-like form that almost seems to be in the process of separating itself into more than one organism. The smooth, delicate surface is strangely structured with some straight lines and right angles, which suggest the intervention of man's activities into the fabric of nature; a node seems to pull together and almost detach itself from the parent cell. A new kind of genesis is revealed to us.

The influence of new materials, new technology, the perva-sive quality of scientific thought has been implicit in many of the manifestations we have noted. But the artist also has more direct ways to show how he has responded to these activities that form such a large part of the life of our times. All sorts of forms and materials, once associated only with nonartistic activities, have now become part of the contemporary artist's language. How often we have recently seen the impact of engineering drawing upon the so-called fine arts! Plans, diagrams, working drawings, factual notations, are all now translated into new forms and given new (and often mysterious) meanings. Just as the sculptor has brought into being a kind of nonfunctional machinery, so the designer in other fields maps out for himself and for us a pattern for construction of a decidedly novel kind.

The falling men of Ernest Trova are examples of this (29). His paintings are like diagrams or patterns for some kind of mysterious activity—neat, impersonal, most explicit, with the competent dehumanization we associate with machine performance. Sometimes the figures are headless; often they are without arms; always they are indistinguishable one from another. We seem to be given a puzzling kind of information in such a work; it is a pattern for action we do not understand. The impersonal inscription which cuts across one corner is an additional obscurity, not an identification. It is certainly not easy to isolate or define the specific symbolism of such work, but it seems to be a disturbing commentary on an energetic and constructive part of our experience.

The diagrammatic approach is further exploited by Enrique Castro-Cid in his curious anatomical paintings (30). The artist has discovered the fascination and the beauty in textbook illustrations of anatomy and has invented a very special anatomy of his own. Penciled titles and notations emphasize the precise and descriptive qualities of a newly invented physical structure. The work is also, of course, yet another example of a point made previously—our obsession with the interior structure of living matter. Such a painting can be looked at from a purely formal point of view, as color, shape, and proportion, but this is only part of the story. Something deep within the ethos of our period makes it now appropriate for the artist to embrace new visual materials and to create an imaginary but vivid and possible world that shares with the world of science certain forms in common.

Finally, let us note the often encountered relationship between purely nonobjective painting and the kind of reality science has superimposed upon the simple reality of common vision. How often we see abstract forms in works of art which bear a striking resemblance to the revelations microphotography has given us: the crystalline shapes and forms of the mineral world, the organic shapes of dynamic living matter. There have been several revealing exhibitions in recent years of objects produced for purely scientific reasons that can also be looked at as pure works of art: demonstrations of mathematical equations, struc-

tural models of organic material. And it is worth noting that these relationships do not seem to be altogether the result of impressions artists have received from their examination of scientific material. Just as Marcel Duchamp seems to have anticipated the superimposed photography of moving bodies in his futurist paintings, so many nonobjective painters and sculptors have reflected, through a kind of cosmic awareness or apprehension of the living quality of matter, shapes and relationships that turn out to be "realistic" in a sense they had not anticipated. The artist is himself a part of nature; his actions follow rhythms found in many other aspects of creation, and we now see closer relationships between the world of art and the world of nature than was the case when the artist based his aesthetic upon a preliminary examination and recording of immediate visual sensations.

Gordon Onslow-Ford's *Who Lives* is such a work (31). Would we recognize it as an individual aesthetic creation if we saw it in another and unrelated context? Or would we perhaps think of it as the enlarged photograph of a cross section of some kind of living tissue? Its cell-like structure and dense proliferating forms seem to indicate a dynamic growth. Much nonobjective art seems to plunge into the very core of the life-stuff itself and to present to us the hidden reality of nature, changed in scale and in emphasis, rather than the surface appearances that may often suggest only superficialities.

In this discussion of signs, symbols, motifs, and themes (all of them considered from the point of view of meaning) we have inevitably concentrated primarily upon recent works in which recognizable forms allowed us to speculate about the reasons for their appearance and their significance, though we have not altogether avoided nonrepresentational work. But we note, of course, that many contemporary artists are not dealing with any of these tangible thematic materials but are building works that can be discussed only within their own terms. For more than fifty years there has been a powerful impetus toward the nonobjective or the nonrepresentational in the field of art.

In a sense, this becomes itself one of the great signs or symbols of our age. It brings up many questions, and answers

will differ according to the ground from which the critic operates. Is it an escape from the sensuous world of visual experience? Is it a penetration into a different kind of experience, as has already been suggested here? Is it a capitulation to the accidental, the irrational? Does its importance lie in the freedom it gives to the expression of the artist's intuition? Is it a negation of personality, or an intensification of it?

Such works seem to reflect the multiple aspects of our experiences and to symbolize their many levels of meaning. Let us look at a celebrated painting by Jackson Pollock, who was perhaps the most powerful individual in the abstract expressionist movement (32). It suggests a kind of automatic creation on the part of the artist; there are, no doubt, elements in it which are (or at any rate started as) accidents, but Pollock must have exerted a kind of unconscious, almost physical, willpower in its final outcome. There is something proliferating, cosmic, galactic, in the ceaseless swirling energy it expresses. The dark poles impose a restraint and order upon the flux of its being. It is nervous, pulsating matter in motion, changing before our eyes. It tells us that the act of creation is more important than the finished product, that the energy and the intuition of the artist now take the place of "subject matter" as it has been historically considered. The artist himself now becomes an instrument, a kind of tool, played upon or used by forces outside of himself and which he can no longer completely control. We find ourselves more and more concerned with the artist as a unique individual and with his work as an active force, and as a result we pay less attention to the finished product. This is without doubt the main reason for the contemptuous attitude some contemporary artists have adopted toward technical matters: the work of art as a physical object for someone else to own or to contemplate is often of secondary importance to the concentration upon the act of creation. Ambiguity and obscurity may result, as does impermanence of material fabrication.

It is a mistake, of course, to think of such works in nonhumanistic terms simply because they do not involve representations of people or the objects of everyday experience. In a very

real sense, the opposite is true. Abstract painting must come completely from within the artist himself; it has the possibility of being the fullest possible expression of the self. But this possibility also introduces a great peril: unless the artist's inmost self is strong or sensitive beyond the normal range, the work can very easily collapse and fumble its way to negativism. We recognize that it is difficult to point to faults, to mistakes, to objectively demonstrated weaknesses, in works that have no points of reference to forms or ideas outside of themselves, but this must not blind us to the quality that exists. Criticism is not only analysis and interpretation but also judgment, and distinguishing between success and failure still must be attempted. The dilemma of modern criticism lies in the fact that no matter what weakness may be identified, it is now considered possible for the artist to say, "I want to do it that way." One has only to read many of the helpless comments in recent art literature to understand this.

There is a self-generating quality about such art that gives it a life of its own unlike anything we encounter in the past. It is impossible to imagine many abstract expressionist works being created part by part: their composition is not an addition of unit to unit but rather a simultaneous development of all elements involved. In Philip Guston's *Sleeper I* we see a highly responsive expression: a color or movement or weight in one area of the canvas demands a response from every other part of the total work (33). This is an art of tension, of challenge. Like other aspects of our life, contemporary art is full of opposites; not the least of these is that at precisely a time when the artist as a practicing, functioning individual seems more interesting to many people than do the works he produces (witness the great emphasis now on artist's statements, photographs of artists in their studios, films of artists at work), the artist himself seems to become more and more a slave to forces outside of himself or to unexplained, even irrational, impulses within his own nature.

The totally nonobjective side of contemporary art is not, however, entirely free, intuitive, fluid. There is also a large body of work that stresses order and discipline of a highly formal kind. This relates to that impulse in the contemporary personality that

accepts the essentially anonymous quality of our social order and seeks to develop a satisfactory and expressive visual language from precisely those elements that in the past worked against self-expression and self-realization. Sven Lukin's paintings are examples of such artistic rigor (34).

The signs and symbols of the art of our times have meaning for us in ways other than those connected only with works of art. The artist is, in effect, a prophet and one who reveals much about us all. We have noted his preoccupation with the machine and its relationships with man; the violence of many of his statements; the emphasis he places upon such subjects as death, decay, and disintegration; such specific themes as the use of the mask, the presentation of the human being through tracks and traces and suggestions rather than through the whole man; the loneliness and loss of identity of many of his humanistic images; his interest in the interior structure of man and all matter; his obsessive preoccupation with space and the new character this has acquired for us; his invention of new forms of organic life. We have suggested some of the influences which scientific thinking and vision and technological developments have had upon him, and we have tried to define some of the implications the turn toward nonrepresentational imagery may have. Surely every one of these points could be discussed in terms of other aspects of society, unrelated to artistic expression, and this would show that the artist is inevitably and inexorably an intimate part of the total culture of our period.

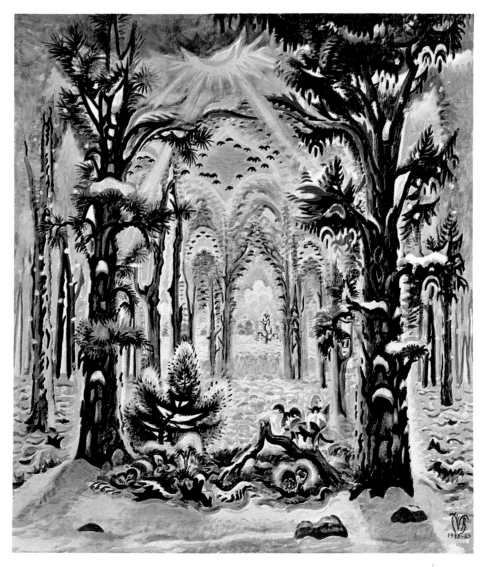

CHARLES BURCHFIELD *The Four Seasons*

II Contemporary Old Masters

There is today a general feeling that the arts in America are flourishing, and in many ways this seems to be true. Certainly there are more artists, more collectors, more publications, more galleries, than ever before. Institutions of higher education have assumed a major responsibility in training artists and in appointing creative people to their faculties. The international reputation of American art has never been so high, and a case could be argued that the historic tide of influence from Europe to America has reversed itself.

The ultimate character our period will establish for itself in the arts depends on how the work of our contemporaries will look to those who come after us. What being produced today will withstand the test of time? The lesson of history seems to be that contemporary judgments are remarkably fallible and that it is only as works are seen in the perspective of time that enduring qualities and final significance begin to emerge.

Every generation must make its own judgments, and many critics today feel that there undoubtedly are artists among us whose works will continue to seem important to future generations. I should like to discuss a dozen of them: contemporary old masters, I have called them, because they are men in their late sixties, seventies, or eighties. They have all over many years shown sustained power and quality in their work; in many ways they have controlled the destinies of American art. Some of them have been the direct forerunners of the developments that two generations of younger artists have launched, while others represent points of view which at the moment are out of fashion. It will certainly be impossible to write the history of twentieth-century American art without taking their work into consideration.

My choice is, of course, arbitrary and personal, and no doubt someone else would make additions or substitutions to it. In discussing them, I have chosen to do so on a purely chronological basis, moving from the oldest to the youngest. They represent a cross section of America, so far as origin and background are concerned. Three of them were born in Europe, two in Germany, who came here only as mature men, one in Russia, who came here as a child; nine were born in this country, in New York, Pennsylvania, Ohio, Illinois, and Wisconsin. Some spent long periods in Europe (one of them some twenty years); others developed with very little direct relationship to the European background. Though their works range over a great variety of methods and manners, all embody significant aspects of what has become an American artistic tradition.

Of the twelve, four have produced work that would generally be considered nonobjective, though it ranges all the way from exciting and highly personal expression to coolly geometric and logical experimentation; three have worked in very abstract styles but still retain close relationships with recognizable materials; and five retain a high degree of representational material in their work, though this, too, varies enormously in intention, character, and meaning.

The arbitrary chronological order I have followed leads us, in looking at the work of the oldest artist in the group, to a figure who in some ways seems to be the embodiment of youth. Hans Hofmann, who died in 1966 at the age of eighty-six, probably had more influence on younger American painters than any of the others in this group; the life-giving power of his work, his personality, and his teaching touched off the abstract expressionist movement here and provided it with some of its greatest monuments.

Hofmann was born in southern Germany in 1880. His early education was in Munich, but he spent the ten years before World War I in Paris, and consequently participated in the excitement these seminal years generated, and was in close contact with Braque, Picasso, and Delaunay. He opened his own school in Munich in 1915, and remained there for fifteen years. His

reputation as a remarkable teacher reached this country through the enthusiastic accounts of a number of American students who studied with him there in the 1920's. "You can teach art but you can't make an artist."[1] he once said.

Hofmann was fifty when he first came to this country in 1930, at the invitation of the University of California in Berkeley, to teach in a summer session. He returned to Germany after this, but came back to California the following year, went to New York in 1932, taught briefly at the Art Students League, and founded his own school in 1933. For many years he also taught during the summers at Provincetown. It was not until the mid-1940's that Hofmann's reputation as a painter began to eclipse his fame as a great and inspiring instructor; artists and critics have been catching up with him ever since. In the last twenty years of his life, when many men begin to show signs of retirement, Hofmann created his most splendid work. ·Every kind of distinction and honor was accorded him, including a one-man show at the Venice Biennale in 1960. A debt he felt toward the University of California was repaid in the most majestic fashion when, in 1963, he presented to this institution an important collection of his paintings and funds for the construction of a special gallery to contain them. No other artist of his generation could have made so great a gesture.

Hofmann has been a great precursor and pioneer and a dominating figure in the creation of the so-called New York School. But above all he has been an immensely inventive and prolific creator, with a joyous feeling for pure color, for complete involvement with the painter's materials, with a wide-ranging journeying through space, which make each canvas an affirmation of faith in being. In a sense, Hofmann's paintings, though ordinarily completely excluding illustrational details, are more naturalistic than those of almost any of his contemporaries (35). They obey the great laws of the physical universe, so far as evolutionary relationships within the compositions are concerned. They are as "real" as a flower or a planet. Yet they are completely and richly humanized, the expressions of deep rela-

[1] Katharine Kuh, *The Artist's Voice* (New York: Harper & Row, 1962), p. 125.

33

tionships between an individual personality and the total universe. He once wrote: "Man himself is nature and so are all his means with which he creates. . . . Man cannot escape nature. No really great work does. A picture has a life of its own and reveals this life in the enlivenment of its substance—its coming into existence calls for the creator—its enjoyment asks in return for a parallel profound sensitive response."[2]

There is something profoundly joyous, life-enhancing, and optimistic about the way in which Hofmann creates. Each painting is a burst into life. Often he contrasts the ordered regularity of severe rectangular forms with organic movements that seem to reflect the dynamism of all abstract life (36). Color advances and recedes; textures involve us in physical surfaces; we seem to breathe more deeply, to live more fully, before such work. He once summed up his work by saying, "My aim in painting as in art in general is to create pulsating, luminous and open surfaces that emanate a mystic light, determined exclusively through painterly development, and in accordance with my deepest insight into the experience of life and nature."[3]

Utterly different is the work and the personality of Edward Hopper, born in New York state in 1882. He studied illustration and commercial art in New York; from 1900 to 1906 he worked at the New York School of Art under Robert Henri. He was in Europe three times between 1906 and 1910, chiefly in Paris, but also visiting England, Holland, Belgium, Germany, and Spain. He was interested in Paris as an architectural setting, and in some of the great realistic painters: Velasquez, Goya, Daumier, Manet. He had little sympathy for the impressionists (though he tried his hand at this manner during this period) and remained impervious to postimpressionism and to such contemporary developments as cubism and futurism.

Hopper lived in New York from 1908, with summers in Maine and on Cape Cod and automobile trips to the West and Southwest. He supported himself by commercial art and did some

[2] "New Paintings by Hans Hofmann" (catalogue), (New York: Kootz Gallery, 1958), p. 3.
[3] Kuh, *op. cit.,* p. 128.

work as an illustrator, which he always disliked. "What I wanted to do," he says, "was to paint sunlight on the side of a house."[4]

An early painting was included in the famous Armory show in 1913, and was sold—his first sale and the last one for ten years. Partly as the result of almost complete neglect, he painted very little until about 1920. From 1919 to 1923 he produced about thirty etchings on New York subjects. His first one-man show was in 1924. Soon afterward he was able to give up commercial work, which had supported him during these years, and his oils and water colors, slowly and consistently produced, have been widely exhibited, with a growing recognition of him as a major figure. In 1955 he received the Gold Medal of the National Institute of Arts and Letters, an honor that has come to very few painters. He died in 1967.

Hopper is concerned with the works of man: buildings, highways, bridges, theatres, railroads, gas stations, lunch stands, lighthouses. Usually his compositions are strangely empty of human inhabitants, though they are curiously permeated with a reserved yet intense humanistic content, and convey a sense of loneliness and finality (37). Sometimes he makes us feel that we are looking at a familiar, commonplace scene for the last time, and this serious suggestion gives it unexpected significance. He often achieves a peculiar emphasis because he looks at scenes we expect to see crowded with people drained of their inhabitants. The human figure, when introduced, is often isolated and uncommunicative. A primary interest is the definition and realization of light as it proclaims itself on architectural forms, but it is not handled impressionistically; and he never allows it to break down the severe structure of the original thematic material.

Hopper is essentially an outside observer rather than a participant: a characteristic motif is a window through which we glimpse intimate episodes of private life cut away from the surrounding urban setting (38). His landscapes also express the way in which man has left his mark on the world of nature, with Victorian houses starkly outlined against clear, endless skies, or highways cutting through the night. In spite of his descriptive subject

[4] Lloyd Goodrich, *Edward Hopper* (London: Penguin Books, 1949), p. 6.

matter, Hopper is in no sense an anecdotal illustrator. The unobtrusive paint quality deliberately avoids brilliance. There is no distracting detail, and a monumental ordering of compositional elements gives his designs abstract power. The artist has said of himself, "My aim in painting has always been the most exact transcription possible of my most intimate impressions of nature,"[5] and he remains the most significant painter of the American realist tradition of his generation.

Hopper was one of the first American painters to see the modern city as a major theme. He did not approach it from the point of view of social comment but rather as a formalist— the effect of architectural masses, space relationships, light on surfaces. His early style was angular and unromantic. Yet perhaps almost in spite of himself he has given expression to the loneliness of the human individual lost in the city in a way that gives his works unexpected emotional overtones. He is a realist whose art transcends what it represents. It is marked by a reserved and restrained emotionalism difficult to define but felt acutely by the sympathetic spectator.

There has been a long tradition in American art of what has been called Precisionism—a kind of clean, orderly, efficient way of seeing the world and of recording it. It is often encountered in the work of naïve or folk artists and has emerged quite independently among some highly sophisticated artists as well. In one way it is an escape from the bewilderingly complex and chaotic character of American life, but in another it is an expression of a peculiarly personal kind of control over our environment.

Georgia O'Keeffe has produced a large body of work of singular purity. She shows perhaps fewer specific influences from earlier artists or other art movements than any other artist included in this group, but she nevertheless links up with a continuing tradition in earlier American art. Just as she has had no real masters, she has had very few followers.

Born in Sun Prairie, Wisconsin, in 1887, O'Keeffe studied briefly at the Art Institute of Chicago, then with the dashing William Merritt Chase at the Art Students League in New York.

[5] *Ibid.,* p. 11.

She free-lanced for a while as a commercial artist, and from 1912 to 1917 taught in high schools and colleges in South Carolina, Virginia, and Texas, beginning at this time a long association with the Southwest. Her drawings were first exhibited in Alfred Stieglitz's celebrated 291 Gallery in 1916, with a one-man show in the following year. In 1924 she married Stieglitz. O'Keeffe has been a zealous traveler: to Europe, Canada, Mexico, Peru, Greece, Egypt, the Near East, Hawaii, Japan, Formosa, Hong Kong, Saigon, Bangkok. She has lived for many years in Abiquiu, New Mexico.

O'Keeffe's paintings are explicit in theme and subject matter, closely related to deeply felt personal experiences, but invariably characterized by an elegant and aristocratic reserve, with an extraordinary control and discipline of the medium. Marsden Hartley once referred to her as a woman of "violent integrity," and the unexpected phrase expressed an essential truth. There is an austere richness about her method. She is seldom completely abstract, but her naturalism creates a world which at times is strikingly independent of actuality.

Even after she had taken up her residence in the Southwest, which is so closely associated with her work, she found the skyscrapers of New York an important motif. Though her pictures are usually small in scale, they can be vast in suggestion, as the great urban structures raise themselves against vaporous skies, as the sun blots out outlines while it radiates against glass windowpanes. It is the city as structure, as a measure of infinity, not as a setting for human activities, that appears in her work. I cannot recall a human figure in any of her paintings.

Later the great bare mesas of the Southwest appear, with a sense of the vast undulating unrolling of the contours to the horizon—uninhabited, timeless (39). Travels in Canada and the Gaspé Penninsula called up the forms of long white barns, windowless and sentinel-like. There was a period when enormous flowers and leaves were brought close to us with monumental seriousness; later the bones she discovered in the desert became leading elements in her compositions—sometimes skulls outlined against distant horizons seen with an almost surrealistic clarity,

sometimes the great oval openings of the pelvis, through which the infinite blue of the boundless sky was revealed (40). Often her painting seems like a glimpse into the infinite.

The material of O'Keeffe's paintings is thin and self-controlled. She is neat, precise, clear, but always completely individual in her method and her meaning. Though she is an artist who is ordinarily loathe to talk or write about her work, she once wrote a beautiful description of her use of the pelvis motif: "I was the sort of child that ate around the raisin in the cookie and around the hole in the doughnut saving either the raisin or the hole for the last and best. So probably—not having changed much—when I started painting the pelvis bones I was most interested in the holes in the bones—what I saw through them—particularly the blue from holding them up in the sun against the sky as one is apt to do when one seems to have more sky than earth in one's world—They were most wonderful against the Blue—that Blue that will always be there as it is now after all man's destruction is finished. I have tried to paint the Bones and the Blue."[6] There has always been more sky than earth in O'Keeffe's paintings, even in those cases where she has not introduced it literally.

Like Hofmann, Josef Albers had a long and successful career as a teacher before, at the age of forty-five in 1933, he came to this country. He was born in 1888 near Cologne, had studied art in Berlin, Essen, and Munich, and had taught in various public schools before he went to the newly founded Bauhaus in Weimar in 1920. There he was active primarily in the glass workshop, in typography, in furniture design, in the designing of containers and letters; he worked with Breuer, Klee, Moholy-Nagy, and Kandinsky. Gropius invited him to conduct the basic introductory course in 1923; two years later he moved with the Bauhaus to Dessau. From 1928 to 1930 he served as assistant director, and he continued his teaching under the directorship of Mies van der Rohe in Dessau and Berlin until the school was closed because of political pressure in 1932.

[6] *Georgia O'Keeffe: An Exhibition of the Work of the Artist from 1915 to 1966,* ed. Mitchell A. Wilder (Fort Worth: Amon Carter Museum of Western Art, 1966), p. 19.

In 1933 Albers and his wife Anni came to this country, where they were invited to teach at the newly founded Black Mountain College in North Carolina. Here began an extraordinarily influential teaching career that was to have lasting effects upon the whole course of American art education. Albers remained at Black Mountain until 1949, but before this had traveled extensively in Mexico, had conducted seminars at Harvard, and had his first one-man show in New York. He has been in great demand as a teacher. From 1950 until 1959 he was at Yale as Chairman of the Department of Design, but found time also to teach as a visiting professor at many other American universities, as well as in Chile, Peru, Honolulu, and Germany. After his retirement from Yale, an analysis of his graphic constructions, *Despite Straight Lines,* was published, as was the monumental *Interaction of Color,* which presents the results of a lifetime of study. Several monumental murals and stainless steel sculptures were designed for important architectural commissions. Many exhibitions in this country and in Europe were held throughout the later years.

Albers did not emerge from the world of the painter, in the old-fashioned, romantic sense of the word; he belongs to a group that demands rigorous logic and experimentation as the basis for carefully thought-out demonstrations of visual presentations. He is very much interested in words and definitions and has provided us with explicit analyses of his intentions and procedures. He considers his work abstract, so long as we do not interpret this word as meaning a departure from nature (41). It can also be called concrete, direct, pure, and absolute, so long as we do not connect these terms too much with the external world or with the idea of finality, which he rejects as an aesthetic possibility. The term "nonobjective" he discards, because this logically implies that such art has no object and is subjective. He would perhaps be willing to characterize his work as "presentational," because it presents us with a pure experience of vision, not with self-expression. He sees art not as an object but as an experience. He has tried many solutions to every visual problem he has set for himself, and to him the creation of a work of art is an intense and

calculating exercise in comparing, choosing, and planning. Consequently we frequently encounter the same formal motif manipulated in an almost infinite variety of ways.

For many years the great theme has been *Homage to the Square* (42). Here a series of three or four rectangles, executed in flat unmodulated color, one within another, give the artist the opportunity to demonstrate the effect of color upon color, as it influences space, weight, and mass and area relationships. There is a definite relationship among all parts of an Albers painting and a complete unification of form. It is executed with exceptional purity and logic and results in a sense of the inevitable. His work is full of visual paradoxes in perspective and space relationships: sometimes we see the same form receding, sometimes advancing. Numerous line studies create a complete world of pictorial space that is extraordinarily active and, though logically related to the world of perceptual nature, seems independent of it.

Astonishingly enough, Albers' paintings remain "painterlike" in quality, and are actually less austere than his theoretical program would seem to indicate. He has been a specific influence on the whole development of hard-edge painters among a younger generation and has undoubtedly had an influence on Op art, though Albers himself has not devoted much attention to the kind of visual color vibration that engages the attention of the Op artists.

Like Georgia O'Keeffe, Mark Tobey has developed with singularly isolated independence. Born in Wisconsin in 1890, he attended Saturday classes at the Art Institute of Chicago at sixteen, and saw there the celebrated Armory show of 1913 —but he was not ready for this, and it had little effect. He first worked as a fashion illustrator, became fairly successful as a realistic charcoal portraitist, drew caricatures of actors for the New York *Times*. In 1918 he discovered the Bahá'í faith, and there is no doubt that the sense of universalism in his work is an embodiment of this. He lived for many years in Seattle and taught in progressive schools there and in England. He has traveled widely in Europe and the Orient and has made at least two pilgrimages to the Bahá'í holy places in Haifa. His work has been

more widely exhibited in Europe than has that of any other American artist; in 1958 he was given a one-man show and the International Prize at the Venice Biennale.

There are early works that suggest a kind of symbolism that remembers Blake and Michelangelo. After World War I there were influences from the art world of Paris. It was in 1935, after having studied Chinese calligraphy and brushwork in a Zen monastery in Japan and while teaching in England, that he arrived at the point from which the whole later rich development has stemmed. This has been unified but not repetitious and in recent years has reached a new peak of power, with a greater use of color, a new exploration of the great circular world-shape, and, finally, the monochromatic sumi paintings, which have an abandon that comes as a great surprise and a wonderful gift (43). Tobey has been compared with Oriental artists, but he disclaims being a mystic, and he has said that it is impossible for a western artist, or for that matter a modern Japanese, to enter the world of Zen.

The themes Tobey has treated are many but unified. Early studies of people gave way to a sense of the city, teeming with humanity. The growth of plants led to a deep preoccupation with space: skies, voids, worlds, galaxies. Religious themes and American-Indian motifs emerge. To Tobey, art is abstract because life is abstract. Conditions become subjects to him: thus the major themes are light, migration, space, scale, unity, equilibrium. Space is a multiple phenomenon, with a moving focus traced by the ceaseless lines of light with which he constructs his paintings (44).

Tobey does not reveal himself quickly, and his work is ill suited to the conditions of most contemporary exhibitions. His paintings are small in scale, deliberate and meticulous in execution, muted in color. His highly personal method of creating mass and space through linear means is so foreign both to tradition and to most current practice that it takes time to enter into the physical structure of his world, to say nothing of its meaning. He has almost nothing in common with abstract expressionism as it is generally practiced. In a group show it is all too easy for the

big, intense, intuitive, active, violent, colorful paintings by most
of his contemporaries to overwhelm him.

To Tobey, painting is essentially a method of and an invita-
tion for meditation. He is a profoundly religious painter, who is
working entirely outside of the traditional iconography of the
religious art we are accustomed to. While other artists of our
times are content to express the overwhelming preoccupation
with space which is our twentieth-century obsession, Tobey is
concerned with the *meaning* of space. The void in Tobey is dense
with life, movement, spirit.

The linear method he employs (the celebrated "white writ-
ing") is not just line in a graphic sense; rather, it describes a path
of light that is always related to the vision of man. For Tobey is
essentially a humanistic painter. We must get away from the idea
that it is necessary to introduce the recognizable descriptive
image of man in order to express a basically humanistic point of
view, just as we must accept the fact that realism is not confined
to the description of immediate visual impressions. We are now
all aware of the concealed or hidden physical realism the world
of science has revealed, and Tobey is even more conscious of the
reality of spirit. His work is in no sense ghostly or immaterialistic.
Indeed, its authority comes from his creation of a highly personal
symbolism that seems to provide a path straight to ultimate
concerns.

Charles Burchfield, born in Ohio in 1893, has created a
very personal world that unites a warm and intimate understand-
ing of the rustic realities of everyday experience with a pantheis-
tic mysticism that gives symbolic values to even his most descrip-
tive works. His training as an artist was obtained at the Cleveland
School of Art (1912–16), but it was many years before he was
able to give up his employment in various industrial firms and to
devote himself entirely to painting. He served in a camouflage
section in South Carolina during World War I, but apparently
never traveled or worked in Europe. From an early period, he
found his subjects in the Ohio countryside, with slightly run-
down farm houses enveloped in great shaggy growths, and in the
quiet side streets of old midwestern towns, with rows of Victorian

houses and overarching trees. When accused of dealing only with the commonplace, he replied, "There is nothing commonplace in the world except the mental attitude of man."[7] He died in 1967.

Burchfield's art has been sustained by a very wide culture; he has acknowledged specific influences from an interesting variety of works of art, literature, and music but has made these so completely his own that it many cases we would not be aware of such influences were it not for the artist's own statements. Particularly interesting is the way in which the continuous unfolding landscape of Chinese scroll painting has found its counterpart in his introduction of several times of day, or several different seasons of the year, into a single composition (45).

Most of Burchfield's work is in watercolor, which he handles in a highly individual and unconventional way. He is one of the few artists who has used this medium on a monumental scale. He works and reworks his paintings, and it is with interest that we often note the dates he so carefully inscribes on his works: these indicate periods of as many as ten or twelve years between the beginning and the final realization of a painting.

Burchfield likes to speak of the "innocent eye" of the true artist. He feels that the artist must be unprejudiced toward nature, even unaffected by the actual forms in nature he is observing. He is brave enough to say that he sees beauty where others see ugliness, and he does this without self-conscious effort. Though his works are full of specific subject matter and detail, his aim is to compose them so that they may be grasped in their entirety in one comprehensive glance. This has been a monumental program in some cases, when he has included successive stages of the same theme in such a unity.

There is something deceptively simple about Burchfield's work. At first glance we see obvious and understandable forms: trees, old-fashioned wooden buildings, horses and buggies, the false fronts of commercial buildings on typical small-town main streets, luminous reflections on a wet pavement, banks of clouds in heavy skies. Only gradually do we realize the life within these

[7] *His Golden Year: A Retrospective Exhibition of Watercolors, Oils and Graphics by Charles E. Burchfield* (Tucson: University of Arizona Press, 1965), p. 20.

descriptive forms, a life that gives organic unity to the entire composition. Industrial themes from the city claimed his attention for a time but were eventually abandoned. At one stage he created dreamlike and fantastic landscapes, with planetary forms moving through dense growth (46). The thick forests, illuminated by unearthly lights, have an almost gothic architectural complexity in their structure. At times the façades of buildings seem to turn into human faces, and objects seem to sway and reform themselves in order more completely to express the character and even the personality of the wind. Burchfield is a naturalist who transforms nature into a world of symbols. He looks beyond the specific. His attitude is well characterized in his statement, "An artist must paint, not what he sees in Nature, but what is there. To do so he must invent symbols, which, if properly used, make his work seem even more real than what is in front of him. He does not try to by-pass Nature; his work is superior to Nature's surface appearance, but not to its basic laws."[8]

Stuart Davis has often been characterized as the most completely and characteristically "American" of the artists of his generation. He established a consistent and logical point of view early in his career and worked with undiminished energy and no loss of quality until his death at the age of seventy in 1964. He never succumbed to the lure of intuition and aesthetic accident; though the importance of his work was early recognized, he had the satisfaction in his final years of finding himself at the very forefront of movements which seemed to have been initiated by much younger artists.

Davis was born in Philadelphia, the son of a newspaper art director and cartoonist. In 1910 he entered the art school recently opened in New York by Robert Henri. The Armory show of 1913 was a decisive event for him; the young artist was included with five watercolors on social themes, but the initial contact with the works of Cézanne, Van Gogh, Gauguin, and Matisse made him feel, he says, "sixty years behind the times." He caught up quickly.

[8] *Contemporary American Painting and Sculpture* (Urbana: University of Illinois Press, 1961), p. 97.

Davis published drawings in the liberal magazines, *The New Masses* and *Harper's Weekly*. He lived at various times in Provincetown and Gloucester and went to New Mexico with John Sloan in 1923, but he was essentially a New Yorker. Influences from cubism and futurism, plus the mechanistic elements of Léger, combine in an important series of experimental works, 1928–30, in which an austere grouping of an electric fan, a rubber glove, and an eggbeater on a tabletop were designed and redesigned with a growing comprehension of their total space, color, and form implications.

Davis was in Paris 1928–30, where he sharpened his visual urban sense. This was further developed on his return to New York. From 1932 to 1939 he was involved with W.P.A. art projects, the Artist's Congress, and teaching. Large murals for Radio City Music Hall, for the W.P.A., and for the 1939 New York World's Fair were executed.

Davis' work is essentially realistic, though not representational in the usual sense of the word, in its use of specific shapes, colors, and details (47). Every element in his paintings is given sharp and equal significance; he uses letters, signs, symbols, straight edges, pointed accents, unmodulated color. Often the total composition is cut into interlocking rectangular areas, with space powerfully realized through color relationships. A characteristic device is the studied use of a sprawling calligraphic signature translated into monumental decorative form. His style has been compared to certain types of jazz, which Davis admired and enjoyed. It suggests not only characteristic American material, but a distinctively American way of seeing (48).

His interest in letters and words as compositional elements in his paintings is delightfully extended into the titles he gave his works. There are puns, alliterations, allusions, a sense of the ludicrous, and often they capture a whole mood with wit and a sort of wild abandon. One recalls such titles as *Report from Rockport, Arboretum by Flashbulb, For Internal Use Only, Owh! In San Paó, Rapt at Rappaport's, Something on the Eight Ball, Colonial Cubism, Ready to Wear,* and *Tropes de Teens.* He evidently delighted in producing statements about his paintings,

which may be either clarifying or confusing according to the reader's point of view. About *Something on the Eight Ball* he wrote, "Impulse to find the Object is product of a normal desire to find out whether anybody else is around. An anatomy of Method must supplement desire. In the last dozen years or so many powerful artists have become air-borne in a proper outward direction. No sightings of any kind of Comfort-Station have been reported so far. In a painting like this, one has stuck to the realm of the sentimental Familiar."[9] He thus punctures the sense of the pompous, of the falsely mysterious, which has surrounded much recent criticism.

Davis' enthusiastic acceptance of the material commercial objects of American life, of its rapid pace and artificiality, made him, in some ways, a precursor of the younger Pop artists, and his method, with straight edges, angular opposing forms, and flat vehement color, points the way toward many younger hard-edge painters. But his healthy delight in sensation and the rather caustic and ironic tone of his work establishes a highly personal quality completely his own.

Abraham Rattner, born in 1895 in Poughkeepsie, New York, is the outstanding expressionist of this group. Before World War I he studied in Washington and Philadelphia and exhibited a characteristic intensity in his quest for knowledge by enrolling in anatomy classes at George Washington University when he felt the need of such discipline in figure drawing. He served in the army in France during the war and was wounded. A traveling scholarship took him back to Paris in 1920 and there he remained for twenty years—the longest period of European residence of any of his peers—and there he might have stayed had not World War II driven him back to this country in 1940. With another famous expatriot, Henry Miller, he made an automobile trip through the South and Southwest, which led to Miller's book *The Air Conditioned Nightmare,* and to Rattner's rediscovery of his native land. He has taught at several universities; his works are included in most of the great public and private

[9] *Stuart Davis Memorial Exhibition, 1894–1964* (Washington, D.C.: Smithsonian Institution, 1965), p. 36.

collections. A number of monumental architectural commissions, for stained glass windows and for tapestry designs, have extended his expressive possibilities.

Rattner's paintings show relationships to the Parisian background in which he worked at a formative stage of his career. They exhibit an unusual combination of proudly definite and important ideas, often expressed in symbolic terms, and intense sensuous love of the painter's materials (10). His color is sumptuous, jewel-like, his handling of paint alluring. To Rattner, art is made up of oppositions, tensions, a balancing of many different elements. Life and art are completely involved with each other, and the complexities of the one are part of the complexities of the other. He sees the artist as dealing with a special kind of reality: he seeks for plastic equivalents or symbols of the object in nature, and feels the necessity of freeing oneself from the object but never neglecting it. His art is always a kind of self-examination; it is positive, a basis for action and for thinking, a search and a finding, not an escape. Though there are many intuitive elements about his work, Rattner avoids the accidental and feels there is a weakness in purely abstract art if it is developed from an exclusively intellectual point of view. Although no contemporary painter has a greater mastery of the purely technical aspects of his craft, he feels that technique for its own sake is unimportant. Even though his work is deeply individualistic, Rattner feels that art is more important than personality, that the work of art is greater than the artist, and he has often spoken of himself as a vehicle or a tool reflecting forces outside of himself. He feels the need of an audience and is very much concerned with problems of communication. Finally, Rattner is one of the chief contemporary exponents of the idea of art as religion: he sees love, light, and magic in art, the godlike quality of creation, and the spiritual aspects of space. He is not afraid to talk about these things in direct and glowing terms.

One of the things separating Rattner from many of his contemporaries is his sense of the supreme importance of meaning, in an old-fashioned sense of the term. For many years he has found Biblical themes that have served him well: not only some

of the great subjects that have engrossed the attention of creative spirits for centuries, but also rare and unexpected episodes for which there is no generally and historically established iconography. The artist has been a student of the meaning of these great texts, rather than a member of any artistic school. But he has gone beyond this and has developed effective new symbols that seem peculiarly well fitted to express some of the most profound ideas of our age (49). To him, the personal and symbolic Window Cleaner and the old shoes of his still-life paintings have been the vehicles for expression no less intense than the Moses, the Pietà, the Last Judgment. Recently, the Sodom and Gomorrah theme has been used powerfully to express his feelings about the Nazi extermination of the Jews.

Rattner has achieved a spiritual equilibrium between outward experience and inner life that is rarely encountered. He himself has said, "Art is also a religion and Beauty is one with God. Intellect, will, and feeling are inseparable. A work of art achieves its fulness from the unification of all three forces. . . . With much hard work, sacrifice of one's time, largeness of mind and great warmth of heart, the inner sensibilities will manifest themselves into an appreciation that will surpass all understanding. A painting if it is achieved at all is made with the help of God. It is as inexplicable as a flower, the song of a bird, electricity, atomic power, or love."[10]

Ivan Albright bears no relationship to any of the other artists we have been considering. This prophet of doom, who has recorded the ravages of decay and death with horrifying intensity, was born in Chicago in 1897 and lived there most of his life. His father was a painter, as is his brother. Albright studied architecture briefly, but these studies were interrupted by World War I, when he unexpectedly found himself employed as a medical draftsman at a base hospital in France. He disclaims any influence from this experience, but there is a strange harmony between this and certain later inclinations in his work. After the war he studied in Chicago, Philadelphia, and New York, worked

[10] *Abraham Rattner,* a portfolio of twenty-four plates (Urbana: University of Illinois Press, 1956), p. 15.

for a time as an advertising artist, and has produced, since the early 1920's, a small body of work which represents a tenacious determination on his part to express in the most personal way themes of serious and imposing character and dimensions.

Albright is essentially a still-life painter, whose work is founded upon the most exacting study of material reality. The multitudinous objects in his paintings are selected with great care and for very specific reasons and are built into semipermanent setups in the artist's studio—a necessary procedure because of the extreme deliberation with which the works are executed. The penetrating, almost microscopic detail in his works does not, however, freeze the objects he depicts into routine representation (50). A disturbing habit of shifting the visual point of view, of introducing variant light sources in different sections of the same composition, create an uneasy tension that is sensed rather than defined by the spectator. Albright has said that he composes *in motion:* he moves around objects, sees them from many different viewpoints, from multiple angles. "Everything seems to move at different speeds,"[11] he says. In addition, he thinks about the objects and the overarching themes of his works from different points of view. He denies that his chief preoccupation is with disintegration and says that he is just as much interested in growth.

Though his works are obviously planned with the most premeditated care, Albright does not make preliminary sketches. He makes a master plan, which is something like the model an architect might construct of a building. Then a complete charcoal drawing is executed on the canvas before any part of the painting is attacked. This is gradually painted, part by part, slowly and with great attention to detail. These individual parts are seldom changed once they have been completed; the execution of a large work may take the artist many years. His amazing picture of a window, started in 1941, was still unfinished in 1962, and its predecessor of a door occupied a full ten years, 1931 to 1941. The only commissioned portrait he has painted required the sitter to pose three times a week for two years.

Albright's method, with its dark underdrawing and its

[11] Kuh, *op. cit.,* p. 25.

piecemeal execution, creates a strangely intense and morbid physical quality in his work. Shadows seem dead, highlights have a curiously phosphorescent, luminous quality. Surface textures are wrinkled and even tortured in character. The human models who are so ruthlessly revealed in his work are ravaged by physical exhaustion. In a few rare works, Albright has extended his highly personal style into the medium of sculpture (51) One must return to certain German masters of the sixteenth century to find anything at all comparable to the morbid intensity of his work.

But the things Albright pursues—strength and power—are there. His works, both in physical being and in intellectual stimulus, make us see things we never saw before and make us think things equally new to us. The artist has discovered, too, the added interrogation titles can give and is noted for the lengthy and involved phrases attached to his works. *Into the World There Came a Soul Called Ida* represents a faded woman with a mirror in her hand, seated at a table covered with the pitiful objects associated with feminine vanity. The famous door, with its funeral wreath and jeweled, furtive, ancient hand, is called *That Which I Should Have Done I Did Not Do,* and the frightening final still life, which Jean Dubuffet characterized as demoniacal and about which he said, "I have never seen anything as frightening."[12] is called *Poor Room—There Is No Time, No End, No Today, No Yesterday, No Tomorrow, Only the Forever and Forever and Forever Without End.*

Alexander Calder, the most important sculptor of his generation, is most widely known as the inventor of the mobile, but he has been active in many more fields than this. Born in Philadelphia in 1898, the son of a famous father who was an established academic sculptor, Calder was trained as an engineer and did not start studying drawing and painting until after several years of apprentice work in this field. In the mid-1920's he went to Paris and divided his time between Paris and New York until 1932. Though widely accepted as a characteristically "American" artist, Calder has spent a great deal of time in France and emerged

[12] *Ivan Albright: A Retrospective Exhibition* (Chicago: The Art Institute of Chicago, 1964), p. 7.

50

as an artist there. There he developed his wire sculpture, after having created tiny, moveable toys from many different materials, which combined into a complete circus, witty, ingenious, surprising. The wire sculpture was a delicate drawing in space; portraits (like those of Josephine Baker and Léger) had elements of good-humored caricature, but they also had impressive formal qualities. Many wire animals were made at this time, again with a crisp, spacious drawing (52). Calder also designed and executed jewelry.

The 1920's saw the creation of several pieces of wood sculpture which seemed to have some of the frank and homely characteristics of folk art, and which also showed the artist's great ability to discover animation and character hidden within the physical form of the original material. Sometimes it seems to have required only the slightest manipulation by the artist to infuse a strong and very personal character into these sculptures. By 1930, again in Paris, Calder had completely renounced representation and was constructing metal and wood sculpture entirely of geometric forms. Soon he was creating wire sculpture with added moving parts, impelled by hand cranks or simple motors. Marcel Duchamp christened these works "mobiles." By 1932 Calder had made his first wind mobiles, relying on currents of air to set in motion disks hanging from delicate wires.

It is with these works that Calder has expressed some of the most basic and characteristic qualities of our age—change, motion, the exploitation of new materials, a sense of the infinite, the expression of specific ideas through highly abstract forms. There is something mathematical about his works, but at the same time they never lose the sense of a warm individual personality, and they are closely related to the world of nature. We see them not only as the tools and instruments of an industrialized society (some of the stabiles are like great tractors or mechanical implements that have acquired a new and frightening kind of life), but also there are spirits of mountains and clouds residing within them (53). The great forms cut sharply through the space that seems to complete and enhance them. We note that even when they are enclosed in architectural settings, it is endless space they

inhabit, not the rigidly defined perspective space of the Renaissance. Calder's work lives happily with nature; perhaps it is seen at its best out of doors, with horizon and sky as background.

There is nothing of the satirical in Calder's attitude toward the machine; he feels that the machine has been only a slight influence on him as compared to nature. He considers himself a realist, because, he says, "I make what I see. . . . The universe is real but you can't see it. You have to imagine it. Once you imagine it, you can be realistic about reproducing it."[13] His work shows the most delicate adjustment of balances, not only in an actual physical sense, but as a mental concept as well—a balance between the physical and the spiritual, between the real and the imaginative.

In his endlessly inventive sense of design, in his delight with "tinkering," in his wit and humor as well as in his complete grasp of the changing qualities of our culture, Calder remains one of the great type figures of his generation. His influence has been great, though in a recent interview, when asked about his imitators, he replied: "They nauseate me."[14]

The career of Samuel Adler, born in New York in 1898, has followed an unusual pattern. Although hc studied at the National Academy of Design at a very early age, he was equally active as a musician, and for many years he played the violin in theatre orchestras to support himself. Far more self-critical than many artists, he did not start to exhibit his paintings until the 1940's, and he was fifty before his first New York one-man show. This at once established him as an artist of great sensitivity and thoughtful power, who has made some important contributions to one of the major artistic problems of our times—the combination of deeply felt humanism with the abstract qualities that are the normal artistic language today. Adler has been an extremely successful teacher, both in New York and during many periods as a visitor on different university campuses. He has traveled widely in Europe, North Africa, and Mexico, and has found such changes in his environment a stimulating factor in artistic activities.

[13] Kuh, *op. cit.*, p. 42.
[14] *Ibid.*, p. 41.

Adler's style, thematically considered, has followed a path that has seemed inevitable to many artists of his generation. Early works were primarily concerned with the human image, developed with a compassionate sense of personality. These became more and more abstract as the artist turned to still-life motifs in which studies of form relationships and the closest and most subtle color harmonies were stressed and developed (54). In the late 1950's and '60's the human image re-emerged, but now with an increasingly universal quality.

Adler's mature work has a content that emerges from work created by an artist who respects himself, the materials he works with, and those to whom he speaks. It introduces some unusual technical elements and recently has given totally new dimension to the collage, which he has raised to unexpectedly monumental proportions. His collages are built up with layers of fine rag papers, applied with strong glues, sometimes stroked or colored with charcoal, gouache, or inks, with varnish applied when the artist wants a sense of transparency. These technical problems are handled with exacting brilliance, with the materials fully controlled, but at the same time with no loss of their inherent beauty. There is a magisterial sense of form, which involves not only the ordered elements within each individual work, but also invokes those larger, more cosmic relationships that carry the work of art out into the total world of physical and spiritual experience and make us aware of gravitational pull and thrust, of infinite space, of ultimates. But in the final analysis, it may be the intensely humanistic quality of these works which gives them their peculiar stature—a humanism that goes beyond individualism (rather than avoiding it, as do so many of our contemporaries) and seems to establish a new level of expression. His most recent work is in the form of painted wood constructions. It is instructive and impressive to see how, at a late stage in his career, he has imposed and expressed his personality in a new technical program (55).

Adler believes, of course, that a work of art has a total life of its own and that it is its own explanation. He is as much concerned with content as with form. He believes that the life of a work of art depends upon the perfect balance of these two ele-

ments, that content without form results in illustration, and form without content in exercise. His years as a successful teacher and his inherent understanding of the human situation have made it possible for him to speak about his work with rare candor and penetration. It is good to be told this, for instance: "We are so preoccupied today with the picture *per se,* that we have virtually forgotten what we have to say. It is better, I should think, to speak crudely, with meaning, than to speak beautifully for the love of words."[15]

Adler's work is not symbolic in the literary sense of the term, but he is unusually sensitive to the life that lies within the forms of the physical universe. His attitude is clearly stated when he says, "I paint, not what I see, but what I feel; not what I think but rather what I am, since art, as I reason it, is the articulation of man's intellectual, spiritual, emotional and esthetic impulses in relation to life as experience. It is not for art, I think, to hold the mirror to nature—to freeze a moment out of time, but rather to capture an impulse and sustain it; in other words, to capture the moment and protract it into all eternity."[16]

Ben Shahn was born in Lithuania in the same year as Calder and Adler. He was brought to this country at the age of eight in 1906, his family settling in Brooklyn. He worked as a commercial lithographer until 1930 while attending high school, university, and the National Academy of Design. In the late twenties he traveled in Europe and North Africa; his first one-man show, in 1930, was mainly of African subjects.

Shahn was deeply affected by the controversial trial of Sacco and Vanzetti, and in 1931–32 produced twenty-three gouaches on many aspects of this case, which exhibit profound concern for social conditions. They are characterized by emphatic pattern, nervous and broken line, an undercurrent of distortion and caricature, and full use of contemporary visual language for communicative and propagandistic purposes. In the following year fifteen paintings on the case of the labor leader

[15] *Contemporary American Painting and Sculpture* (Urbana: University of Illinois Press, 1959), p. 189.
[16] *Contemporary American Painting* (Urbana: University of Illinois Press, 1951), p. 157.

Tom Mooney led to Shahn's employment by Diego Rivera to work on the ill-fated Rockefeller Center frescoes, which were never completed.

Meanwhile, Shahn had begun to record New York street scenes in photograph and developed many of these as paintings under the Public Works of Art Project. In 1934 his designs for murals for Ricker's Island Penitentiary, New York, were rejected by the Municipal Art Commission. In 1935–38 he was employed by the Farm Security Administration as artist, designer, and photographer. A large fresco was finished in 1937–38 for a federal housing development in Roosevelt, New Jersey, where the artist took up permanent residence. During the war he designed posters for several different government agencies. He completed thirteen large murals for the Bronx Post Office, New York, but his studies for murals on the Four Freedoms for the St. Louis Post Office were rejected. In 1940 he won a competition for murals for the Social Security Building in Washington. During the 1950's, Shahn was in increasing demand as a teacher, and he served as a visiting instructor in a number of art schools and universities. In 1956–57 he was appointed as Norton Professor at Harvard, and the lectures he delivered at this time were published as *The Shape of Content,* an extraordinarily lucid statement of his philosophy. Throughout this period, Shahn executed many commercial commissions for business concerns and magazines. His work has been exhibited in Europe, South America, and Japan, and he was one of two Americans to be shown at the Venice Biennale in 1954.

This record shows Shahn to be an artist more closely related to the social movements of his time than any of the others we have considered, though he has said that he works first of all for himself, not primarily for large numbers of people. He does not consider that his work as a photographer has affected his painting but that the influence has been the other way around. He has found that photography, however, has sharpened his vision of the specific. Shahn considers himself a realist and believes that this term is one of the noblest designations that can be given to an artist.

Shahn has successfully bridged the gap between clarity, persuasiveness, and personal expression. He has combined the unexpected directness of candid photographic vision with monumental form and a powerful personal symbolism, dealing with some of the most basic problems of our times (labor movements, race relations, atomic warfare) (56). He often makes use of lettering and inscriptions; he is interested in the emergence of intensely human expressions within the confines of an industrial society. Mechanistic social forces mingle with nature and memory (16). Technically, his uneven, dry-brush line, his strong contrasts between positive and negative shapes and spaces, and his subtle color modulations within firmly defined areas have had wide influence, particularly in the field of serious commercial work.

Shahn sees in prevalent nonobjective art a rejection of man, his visions, his philosophies, his future. He is more concerned with concrete subject matter than are most of his contemporaries. He has written: "There is no moral reason why art ought to go on if it has nothing further to express. Nor is there any moral or aesthetic reason why the public ought to bend the knee in reverence before the mere fact of art. We might assume that art is important only if it essays to be important. If it adopts the manner and outlook of a minor expression, then a minor expression it will be. If it aspires to be an aesthetic of double talk, just that will be its position, nothing more; and life will walk around it and let it alone."[17] Shahn's art is a major effort by a serious and competent artist to establish contemporary art as an important factor in the humanities.

All of these artists, from Hofmann to Shahn, have left a lasting imprint upon the art of our times. But they represent ideas and points of view that in many ways were formed before World War I, in a world unlike that in which young artists today are being shaped. How are their lessons to be modified in the face of new conditions, and what directions have their successors taken?

[17] *Ben Shahn Exhibition at the Downtown Gallery* (New York: The Downtown Gallery, 1959), p. 5.

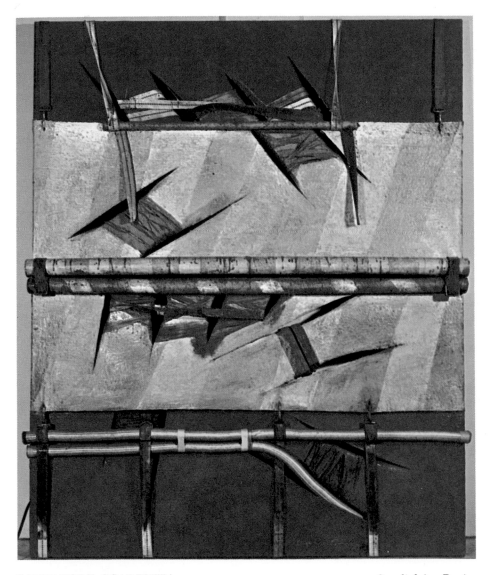

SALVATORE SCARPITTA *Sundial for Racing*

III Rejection and Renewal

The generation that reached artistic maturity immediately after World War II rejected many of the most characteristic qualities of those artists who proceded them. They no longer found description or social comment legitimate artistic aims. Precisionism seemed an impossibility, symbolism an outworn refuge. The new mood demanded complete self-expression, a spontaneous and intuitive language, and an appreciation of the creative possibilities that lie within the accidental. They wanted to retain all the purity and intensity of highly abstract or nonobjective art, but to flood it with personal feeling. The result was the movement called abstract expressionism, which for a decade, beginning in the mid-1940's, was the dominant American style. It is still a potent factor in our artistic life, though it has now reached into its second generation. Among the older artists, it was of course Hans Hofmann who pointed the way, both by his work and his teaching.

Some of the key figures in this development are still producing vital work, but others died young, and their achievement already retreats into a historical perspective. We think of the subtle and calculating Bradley Walker Tomlin (57), one of the first to realize the possibilities of a hidden calligraphy in his paintings, whose compositions move out in many directions. Still a potent influence among younger artists is Arshile Gorky (58), who more than twenty years ago was designing organic forms with a lush richness that seemed to probe intimately into the innermost recesses of physical existence and to invest them with a highly personal character. The aggressive black-and-white statements of Franz Kline shouted decisive messages and at the same time expressed changeless relationships of balances and gravities

(59). The most influential of the entire group was Jackson Pollock, whose physical involvement with the act of painting, whose cosmic compositions, seemed to present a new aspect of being and to establish a climax for the whole movement (32). Artists who are still producing important work were among other early adherents: Philip Guston, whose career shows an interesting and remarkable shift from a successful early phase as a sophisticated figure painter to work of a highly intuitive nonobjective nature (33), and Robert Motherwell, whose spontaneity has been demonstrated on a grand scale.

All of this now represents an art of maturity, which by this time has received every possible mark of individual and cumulative success and acceptance. One of the most powerful motivating forces in cultural change is the deep-seated desire a pluralistic society like ours has to turn away from anything that has become established. Even when something is completely successful, when it is responsive to current needs, when it is flexible enough to react to subtle changes in thought and action, we feel the need for change simply for the sake of change. This is particularly true in times like ours, in which developments in all aspects of our culture have been speeded up enormously, in which the dissemination of new ideas is almost instantaneous, and in which high value is put upon originality. The emphasis we put on youth, both physical and emotional, is an indication of this in one field, just as the rejection of an artistic style as soon as it reaches maturity is in another.

Recent art is a striking illustration of the contemporary mood of rejection and revolt. Every kind of traditional art has been challenged, and it has taken a surprisingly short time for art forms developed only a few years ago to be classed as "traditional" by a younger generation. Whenever a style reaches a point of maturity, when its problems seem to have been resolved, when its youthful adherents have become contemporary "old masters," it runs the danger of becoming solemn and self-satisfied, perhaps even pompous, or at any rate of being so characterized by youth. Abstract expressionism has now reached this phase. The great initiators and innovators of this movement are

now men and women in their fifties and sixties, most of them widely acclaimed and showing all the marks of great worldly success, represented in all the great museums, voluminously published, and handled by astute dealers who are of course anxious to keep them before the public. They have now become, in almost record time, a kind of monument from the past and as such are suspect by a younger generation of artists. Their art is still a painted illusion of space and movement and internal development that represents the continuation of an aesthetic ideal that has remained fundamentally unchallenged since the Renaissance.

But it is being challenged now. Young artists today are interested not only in change, but in reform. They feel detached from the past, though they are still influenced by specific monuments of the past. These monuments are, however, precisely those that are outside the long stream of artistic expression that reached its culmination in abstract expressionism. In place of the sophisticated meeting and mingling of chance and individual creative activity, we find a new interest and cogency in the naïve, the primitive, the exotic. Often we feel a deliberate avoidance of what academic critics used to refer to as "taste." Forms originally created as a specific means of nonliterary communication, often with undercurrents of magic power, take the place of more sophisticated art objects—and of the direct study of the world of nature—as sources and influences. The immediate past is viewed with distrust, and we reach into remote periods and places for inspiration.

It is a French, rather than an American, artist who has produced perhaps the most extreme examples of the self-conscious primitivism that is a significant element in our rejection of the artistic traditions of the immediate past. The ugly scrawls of Jean Dubuffet, intentionally brutal, evoke images that seem to come from the childhood of art. It is a childhood, however, that is weary and depraved. It is a retrogression rather than a development. Yet it is certainly not without power, and we are forced into admiration for an artist who deliberately strikes out against all qualities of content, form, and technique that have traditionally been held up to us as the proper material for artistic expres-

sion. The misshapen figures in his works are disturbing in themselves, and they arouse still more disturbing thoughts as we measure them against both remote and immediate past styles.

Dubuffet's painting shows us one way in which the human image—which for centuries was an object of veneration and aesthetic delight—has been debased in our times. The breakup of the human image has happened spontaneously and independently and in a number of different ways. It is one of the great paradoxes of our times that, in the increasingly man-made environment in which we live and operate, man no longer seems the dominant figure. As his actions are more and more controlled by the very forces he himself has created, his identity diminishes. In Dubuffet's painting it has retreated into a kind of primitive, symbolic shorthand.

In other cases, the image of man as a complete and identifiable being seems to merge into the material of the work of art, or it loses itself as it is fragmented and torn asunder. Elias Friedensohn's *The Secret* (60) shows us two faceless beings whose material form has no boundaries separating them from their surroundings. Are these beings emerging from the very matter of existence, or are they forms dissolving into surrounding space? Is it the end or the beginning? This is a question we ask about many aspects of our culture.

It is a different kind of breakup we encounter in Larry Rivers' *Dead and Dying Veteran* (61). Parts of the image are simply not there; details of other parts have been smudged or erased so they become obscured. There are holes in the composition that seem to call for something to happen which is not taking place. A curiously unfinished quality is joined to the idea of the finality of death itself. Are we looking at different aspects of the same image or at distinct and separate images? Again, we are left with a question rather than an answer.

Many years ago Wilhelm Worringer called attention to "that uncanny pathos which attaches to the animation of the inorganic." This is inherent in the aesthetic relationship that has developed between man and machine; it is a two-way proposition: the artist can infuse into machine forms the feelings and

emotions of the human being, or he can translate the human image into machine-like structures. Both of these methods have played an important part in the directions contemporary art has taken as it has rejected the almost exclusively humanistic bias of its immediate past.

We have already commented on the machine as a symbol and have called attention to the humanization of machine elements by Richard Stankiewicz (1) and to the design and construction of nonfunctional machines by Lee Bontecou (2). Perhaps it is significant that this is done so that the entire transaction is given the added dignity of age, a sense of the passage of time. Bontecou's untitled constructions, monochromatic, closely organized, seem stained with use. These are not the sharp new products of a fashionable stylist but have survived the ages and have assumed a significance only time can give them.

The forms that have been mentioned here remain symbols—imaginative and personal uses of the machine side of our culture. But machines "work": we may admire them as we see them in repose and speculate about their power, but the test is what they produce. We have yet to see the production line introduced into the art gallery (though we may not be surprised when this happens), but we see an increasing number of works of art in which physical activity is part of the total design. This is most frequently an optical matter, a question of color vibrations, but it is also found in machine art that is motorized or in other ways activated. (Not long ago a New York dealer told me that he refused to handle motorized works of art because he was tired of having his patrons call him up and complain because "my painting won't work.") The limits of working in recent machine art seem to have been reached by the French sculptor Jean Tinguely, whose constructions are designed to destroy themselves. The final phase of their exciting life is their explosion, and the construction is violently reduced to the junk from which it originally emerged. This certainly solves some complicated problems of disposal that arise about many recent works, and it may be that it is logical for us to think more often and more seriously about artistic destruction as well as creation. Mechanistic art is summed up by Andy

Warhol, who is reported as saying, "The things I want to show are mechanical. Machines have less problems. I'd like to be a machine."[1]

As artists of the past two generations developed a language appropriate to the ideas of their times, one of the things they rejected from nineteenth-century academic art was its literary quality. Everything that was related to literary expression was avoided or suppressed; art became more and more a matter of pure visual sensation. Now a younger generation has rediscovered the possibility of a new kind of "literary" art: not illustration in the old-fashioned academic sense, but something that can be read in a way unlike that which appeals only to our purely visual perception of form, color, movement, texture, space—almost everything that has happened since the advent of impressionism.

And of course we can see why this was bound to happen. We are all subjected to a barrage of letters, of words, at every turn. Headlines in newspapers take up more and more space; streets and highways have called into being an unholy growth of signs, huge in scale, aggressive in character; even the most purely visual aspect of contemporary communication, TV, turns out to be constantly interrupted by the word. The amount of printed material that flows through the daily mails is colossal, and at times we feel inundated by a flood of words.

Consequently we find more and more recent artists introducing words and letters into their creations. Often these bear a distinct and obvious relationship to the sign language of the commercial world. Stuart Davis, among older artists, was one of the first to exploit the word as an artistic form, and many younger artists have approached the possibility in a variety of ways (48). Frequently the artist makes a particular point of producing letters that are impersonal, mechanistic, regular—a blunt, even banal, form. Often he prefers stenciled letters to free forms. The models are far more frequently newspaper headlines than they are the traditional letter forms that were developed in the past by

[1] "Modernism," *Encyclopedia of World Art,* X (New York: McGraw-Hill, 1965), 203.

the action of man's hand with a tool, whether it be a pen or a chisel.

Llyn Foulkes's *Post Card No. 2* illustrates many of these points (62). The letters are of a kind ordinarily used only for purposes of immediate communication (in signs or newspapers), but they are now used for a different purpose, as formal elements in a total design. Their mechanical character, which conveys a message as empty of meaning as are their very shapes, is repeated in the ruler-straight lines of the painting's principal area. All of these elements make a strange contrast with the subtle modeling of the partially presented nude figure, which, with its startlingly photographic quality, harmonizes with the mechanistic character of the other major artistic elements. We notice the consistency that exists between the way the human figure is cut off in a purely arbitrary, snapshot-like way (face and arms missing) and the way in which the numerals at the top are also sliced off. A margin at the left is not repeated at the right. Everything about the picture suggests that it is a larger work which has been mechanically and brutally reduced in scale by being sheared away at the edges.

Totally different is another use of letters that turns them into mysterious symbols—the characters of an unknown language, or familiar letters put together in combinations we are unable to comprehend. The complexity of contemporary experience finds expression in the use of forms that were specifically designed for clear communication but are no longer functioning in that way at all. This is one of many examples we could cite in which forms or constructions that were designed for completely practical and functional purposes have assumed a new quality and are now seen as expressive and frequently obscure personal symbols. An untitled work by Robert Courtright illustrates the point (63). Lines of letters (in most cases cut in such a way that the entire letter is not visible, as in Foulkes's painting) are stretched across a wood panel, which also introduces three-dimensional architectonic forms beneath the cloth collage. Although we may see the work entirely in terms of texture, tonal

values, and a subtle interplay of movement and form, certainly the mysterious obscurity of the unreadable inscriptions adds a quality that can affect us profoundly. Do we feel that language is no longer enough, that we are searching for means of communication which go beyond the printed word, upon which so much of our culture has been based? Perhaps the artist would tell us that these ideas did not occur to him in the composition of his work, but something in the climate of our culture has impelled him to use letters and words for new purposes and in a completely novel way.

Just as there has been a revolution in subject matter, in symbolism, and in certain fundamental relationships between the artist and society, so there has been in our times a revolution in the materials and techniques now at the artist's disposal. These have had a profound influence on both form and content in recent works of art.

Materials and techniques that were developed primarily for industrial use have been redirected into personal and expressive channels. Most of these processes were developed in order to speed up mass production, to reduce costs, to do away with laborious long-term hand methods, to satisfy a vast consumer market that demands goods of constantly novel design and of identical standardized quality. Are these same demands determining factors in the production of works of art? Certainly many young artists are impatient, unwilling to undergo the long and laborious training of technical craftsmanship that was traditionally a significant part of their education. Individual expression more and more becomes equated with swiftness of execution, and it is not only the expense of such time-honored techniques as bronze casting and stone carving but also the comparative ease of execution in new materials, their light weight as compared to the heaviness of older kinds of materials, which lead the artist to experiment joyously with every new material and method offered him.

Colors produced for industrial purposes dry rapidly without changing their essential character. Plastic paints and acrylic and vinyl resins offer many possibilities that were unavailable to the

painter of the past: impastos that do not crack, a choice between mat or glossy surfaces. New plastic materials like polyethylene, polyvinyl, polyester resin, plexiglass, and fiber glass invite all sorts of experiments and suggest the increasing use of polychromy in sculpture. Sculpture is no longer almost entirely a matter of carving or modeling or casting; the use of wire screening, of cutting and fitting, of welding, of materials like aluminum, magnesium, stainless or structural steel, lead to new forms and new feelings.

The boundaries between two- and three-dimensional arts become indistinct, and more and more we are unable to distinguish between sculpture and painting, just as every print technique may now be used in a single plate. Hand techniques retreat into the background as mechanical methods are used for new purposes. Movement becomes not a matter of suggestion or illusion or symbol but an element of motorization. Free elements in sculpture may be suspended by magnets. A leading element in the use of such new materials and techniques is the belief that each material should preserve its own visual characteristics and not be an imitation of something else. Craftsmanship, which used to be a manual skill, becomes more and more an appropriate use of mechanical methods.

The delicate wire patterns of Richard Lippold could never have been produced in an earlier age (64)—not just because they are constructed of materials that are the product of an industrial civilization, but because they reflect a new conception of artistic reality. These slender threads of evanescent wire establish complex three-dimensional forms through which infinite space moves with an active rhythm. They suggest actual industrial forms which have been etherialized, infused with a totally new quality, and are like models of the internal structure of abstract matter. Such works make us feel that we are probing into the very heart of material existence.

The new materials allow the artist all sorts of freedom, all sorts of extensions, which he never enjoyed before. Sometimes the results are baffling, mysterious. There is a secrecy about how some effects are realized which is not the least of the attractions

of recent work. Calvin Albert's *Outer World,* for instance, remains a puzzling kind of object (65). Parts of it seem to be realistic mechanical impressions of actual forms and materials, other parts are arbitrarily and architecturally designed and organized. It astonishes us, if we still think in terms of all earlier forms of traditional sculpture, to find a monumental work so light in weight, due to its material, a pewter alloy. We do not readily understand how thin materials, like delicate fabrics or tissues of transparent papers, seem to have been cast into solid form.

It is understandably in the field of sculpture that the use of new materials has had a particularly decisive effect, because it is now possible to produce works of monumental scale that are done relatively quickly and are light in weight. Consequently they can be easily transported. We more and more frequently see large, three-dimensional works in exhibitions that even a few years ago would have been forced to exclude them. The remarkable success Frank Gallo has had with his polyester resin life-size figures, reinforced with fiber glass and wood, are examples (66). Several replicas of each work can be produced, almost on a production-line basis, but the artist's use of color and variations in tone give considerable individuality to each separate work, even when it is identical in its actual three-dimensional form. Gallo's work represents most interestingly the new seriousness of the artist as he turns to the human figure as a major theme with a remarkable intensity and sharpness of observation, and a mastery of expressive pose and gesture which seems to be directed from within. Surely it is partly the curiously slick surfaces, which almost reflect the surrounding environment, the strangely bulging, slightly inflated forms, which convey a strong sense of inner activity.

Among the painters, the use of acrylic on canvas has led to exciting results. The almost instantaneous drying of pigment has made it possible to combine colors with a spontaneity no other medium allows. The floating of large color areas, one across the other, without obscuring the quality of successive layers, opens

up new possibilities. The magnificent paintings of Paul Jenkins, like *Phenomena Point Swing and Flank,* are developed with a majestic mastery of the new materials (67). The artist, apparently in complete control of his medium, varies the edges of the color areas from the sharpest distinction to a vaporous merging with the white background; colors flow over each other with a fascinating interplay of influence and variation. The life and movement within such a work has its relationships with the great rhythms of nature—the circulation of the blood, the movement of sap, the flow of the elements. Such effects could never have been achieved with the traditional painting materials and techniques of the past.

The contemporary artist has not only welcomed new techniques and new materials, but he has also combined materials with increasing boldness. The collage, the found object, the assemblage—these forms and methods have led ultimately to the happening, in which nearly every aspect of existence and experience become part of a possible medium. Motion becomes not a matter of suggestion or of illusion, but of the use of actual moving parts; actual light, actual sound, are drawn into the orbit of the artist's materials. Much of the work that comes out of such an ambient is deliberately transitory. The complexity of contemporary experience and the breaking down of barriers are suggested by the combinations that contemporary art has produced.

Recent figure paintings by Willem De Kooning, for instance, introduce, above the swiftly realized figure itself, a smiling face that has been clipped from a magazine advertisement. The artist makes no attempt to integrate the painted part of his image and the photographic reproduction. The head is not intended in any sense to be an illusion but remains exactly what it actually is, different in scale from the symbolic body to which it is attached. The artist picks and chooses whatever materials will best accomplish his purpose, with no nonsense about consistency or logical relationships. Robert Rauschenberg has been a leading spirit in bringing about such new combinations (68). Prints, photographs, silk screens, coke bottles, wooden boxes, clock

faces, lumps of coal, and many other things find their way into his "combines." One feels that everything in his environment is available to him as he builds his compositions.

That it is possible to handle such combined operations with wit and charm as well as with shock and surprise is shown by the sculptor Marisol. The effect of her combinations of three-dimensional forms, sometimes mechanically realistic, in other cases highly simplified, with flat painted surfaces, her introduction of actual articles of clothing, shoes, and so on, is often devastating. A favorite theme is the introduction of actual casts of the artist's own face and hands into the blocklike forms from which her figures are shaped. There is an insolent bravado about the bather, painted simply and directly on a flat panel, who suddenly flings out a shockingly three-dimensional wooden leg (69), or the way in which an almost classically refined profile is sharply outlined on the surface of a rectangular block of wood. The artist's method of grouping the three-dimensional figures in unlimited space, rather than within rigidly confined and defined areas, is a further indication of the new dimensions within which the contemporary artist works.

Much of the mood of rejection of all the traditional forms of art is undoubtedly the result of our attitude toward the concept of reality. For a very long time in western art, reality meant the imitation of nature: the creation of equivalents to objects and experiences that existed separately from the work of art. This sort of reality is of less and less concern to the artist today. In its place two new realities become constantly more important. One of these is the reality of the material itself. The other is the reality that dwells deep within the human spirit.

To the artist, the absolute in reality may be those elements with which he builds his works—color, form, line, texture—not the suggestion of something else, not the illusion of another kind of experience. A work of art may have the form and texture of an object in nature, plus a few simple but somehow strangely significant scratches that suggest the act of man upon such an object. We look at it much more as we would look at a great boulder than the way we would look at a Renaissance painting. An

almost purely material satisfaction results from the weights and balances of the main mass of such a work as it is pinned into place by areas on either side.

The reality of material is expressed in another way by those artists who find in nature the forms from which their works are made and who transform them, sometimes by surprisingly slight changes, into works of art. With some artists the path from nature to art becomes constantly shorter. Alvin Light's *May* (70) looks at first glance simply like an imposing piece of wood that has been changed and given new character by the work of wind and weather; it is only gradually that we realize to what degree the artist has impressed his own personality upon it.

It is interesting to note how frequently the material, which becomes for the artist his ultimate reality, is ancient, weather-worn, or decayed. A sense of antiquity emanates from Light's sculpture, and a work in cement, iron, and wood by Robert Mallary, *Lot's Wife,* is scarred and cracked with the effects of time (71). While one group of artists, in their use of new materials and industrial technology, suggests the emergence of a sharp and efficient materialism, another concentrates upon the breakup of matter, upon the decay of physical form. And indeed we are in many ways constantly aware of a heavy burden from the past, of the accumulation of outworn forms. Often works bring together an incredible variety of materials.

It is characteristic that in a complex and pluralistic culture like ours the boundaries among the different art forms disintegrate, and more and more frequently we encounter total art forms. Indeed, some aspects of contemporary art seem to carry the integration of the arts further toward a point of unity than has been the case since the Baroque period.

For example, we no longer are sure of the distinction between painting and sculpture. The introduction of actual three-dimensional forms into paintings and the reliance upon polychromy in sculpture are encountered with increasing frequency. Salvatore Scarpitta's *Sundial for Racing* is an example (72). Called by the artist a "canvas relief," its surface thrusts forward with a series of tubes and belts attached to the basic plane, which

in turn is slashed in such a way that openings are created into the space behind it. It is an object in space, not an illusion of space on a flat surface. Here the character of the work is at once highly abstract in form and design but completely actual so far as physical substance is concerned. It is a stimulus to thought rather than a symbol of perception.

A further extension of this aspect is the increasing number of works that involve the spectator in the total form or that consciously change according to the environment in which they are placed. We see an increasing number of works whose shining smooth surfaces function as mirrors; we are involved, not only with the form contained within the work of art, but also with the reflection of the changing world outside of it. Charles Frazier's *Object of Affection* (73) can be gay or gloomy according to its location or installation: its shiny global surface turns light and atmosphere outside of its own substance into a new kind of planetary system.

There is a strong impulse in much contemporary art to get away from the "hand made" look, which for a long time has been one of the chief ways the artist has imposed his personality upon his material. But the greater and greater emphasis on mechanical methods, the rebellion against social realism and abstract expressionism, the emotional disengagement that many artists now seek, lead to an effect of anonymity about much present work. The use of stencils, of spray guns, of screens, takes the place of involvement with brush and pigment, or of manipulation of the modeler's tool. There are both emotional and technological reasons for this aesthetic anonymity—the desire to "play it cool" in the face of complexity and the desire to create images of the industrial world.

Thomas Akawie's *Dr. Strangelove* has created shapes with mathematical exactness and records the patterns of materials and forms that have been used as stencils (74). The artist remains discreetly unidentifiable so far as personal handwriting is concerned. The work has been composed in the way an architect designs a building, rather than evolving in the actual process of involvement with the media. The perfect symmetry of such work

gives a sense of the absolute. Or note the way in which H. C. Westermann delights us and engages our attention by boldly tying a knot in a large form created out of laminated wood (75)—in no sense is this a carving in the long tradition of wood sculpture but a machined object which achieves a character completely unlike that associated with everything that we call self-expression. One recalls Ad Reinhardt's statement, "The laying bare of oneself is obscene."[2] Certainly the works we have looked at here are the furthest possible remove from everything we know as romanticism.

A combination of several characteristics of the contemporary mood in art—its preoccupation with the machine, with words and letters, with techniques and materials developed for mass production, with anonymity—makes understandable, even inevitable, the appearance of Pop art. This movement reached its height when Robert Rauschenberg received the top prize at the 1964 Venice Biennale but seems to have quickly subsided. No movement in recent times emerged so swiftly, excited so much comment in quarters that are not ordinarily concerned with art, and wore out its welcome so soon. Pop art represented a new realism, in which art becomes an object like any other object in the material world, in which the banalities of everyday life are accepted completely and uncritically, in which ready-made subject matter is embraced. Pop art suggests the swift obsolescence of ideas that is characteristic of the world of commerce, the use of ephemeral materials, indifference to permanence.

Pop art accepts the visual assault we have experienced from advertising, comics, television, packaging. It is indifferent to craftsmanship and avoids the personal touch. It does not create symbols, and it is not satire. It is in a sense a protest against all forms of earlier art, but it is not in itself a comment on life. It accepts and enjoys commonplace images; it uses words not as meaningless symbols or as mysterious expressive forms but in the purely factual way that they are used in road signs. When it first attracted wide attention in the early 1960's, it was considered by many artists and critics as an insult to art. In a way, it has been

[2] *Ibid.,* p. 208.

the final challenge to traditional art, the final affirmation that there is nothing mysterious about art, the acceptance of the banalities of everyday life. Rauschenberg has said, "I feel sorry for people who think things like soap dishes or mirrors or Coke bottles are ugly, because they are surrounded by things like that all day long, and it must make them miserable. There is no poor subject."[3]

But almost in spite of himself, it is impossible for the artist not to develop a personal style. An astonishing range and variety of work is embraced in the totality of the group that is ordinarily included under this heading. James Rosenquist takes details from the enormous commercial representational paintings used on highway billboards (76) and, while retaining unchanged their original content and quality, combines them in such a way that we seem to be subjected to a whole collection of such signs at one time. Sometimes an unexpected change in scale gives an astonishing new character to familiar forms, as in Roy Lichtenstein's enormously enlarged comic strip frames, in which the brutal impersonality of form and technique overpower the spectator (6). The great sign painter is Robert Indiana, whose meticulously ordered works rely upon the straight edge, the unmodulated flat color surface, the compass, and the stenciled letter for their character (4). Unlike many Pop artists, however, it is impossible not to read symbolic significance into the choice of specific words he uses, though they do not immediately reveal their full meaning.

Vast enlargement of scale also marks certain works by Claes Oldenburg, whose monumental painted plaster hamburgers and slices of pie suggest a kind of compulsive and gargantuan appetite on the part of the Pop artists. It is the standardized mass-produced menu of the drugstore counter that feeds this artistic appetite. More recently, Oldenburg has become engrossed with mechanical forms, chiefly office appliances (typewriters, telephones, electric fans) that have lost their potency, have gone limp and soft, made as they are from spineless fabrics. Another obsessive image with the Pop artists is the bathroom; by this time,

[3] *Ibid.*, p. 203.

plumbing fixtures have become part of the standardized iconography.

Wayne Thiebaud has said, "Realism for me . . . is what happens in a clean, well-lighted space . . . what happens to reality divested of its literary conditions. . . . Abstract expressionism said you had to be involved, to search for individual consciousness and sensibility. The New Realists, or Pop artists, say it's possible to be cool, not to have a personal feeling for the object. The new artist is saying maybe you can do your art . . . without any involvement at all."[4] His paintings, with figures and forms starkly presented against a nonenvironment of slippery white pigment, completely embody this attitude (77).

Introduction of images that have developed as the result of nontraditional forms of visual communication become increasingly familiar. Sometimes artists take the movie frame as a motif and present the same image from different distances. The painter who has most completely grown out of the comic strip is Peter Saul, as in *Ice Box No. 6* (note again the obsession with eating), whose works include an almost total amalgam of the most banal elements of this popular form (78). Tom Wesselmann has introduced elements of collage into his still-life paintings, but, unlike the collage artists of an earlier generation, with no desire to transform the meaning or character of the original images (79).

Pop art is unlike almost all other forms of art in that it is possible to talk about it, to analyze it, without looking at it. Its complete content can be astonishingly often stated in words. There are those who feel that the critical writing this movement has inspired is more interesting and important than the work itself. At this point, it seems unlikely that Pop art can go much further. Once we have received the message, its meaning is clear, and it holds no more surprises for us. However, the best of the Pop artists are better than this program suggests, and some of them, like Rauschenberg, have either retained or rediscovered some of the personal expressive qualities of abstract expressionism.

Objective reality in the past was almost invariably trans-

[4] *Ibid.,* p. 207.

formed or transfigured by the artist or was imbued with symbolic significance. A new attitude toward reality is suggested by the Pop artist, who views the object of art as being simply another object in the universe of things. Closely related to this is the introduction of "real" objects into works of art, a development which has already been discussed by inference as we have seen the breakdown of the boundaries between two- and three-dimensional forms and the conscious withdrawal of the artist as a uniquely expressive composer. Rauschenberg has said, "A picture is more like the real world if it is made out of the real world."[5]

George Segal's plaster casts of actual people, surrounded by practicable tables, chairs, beds, windows, other objects of furniture, have already been mentioned (17). The final stage in the introduction of material reality into the world of art is seen in the beer cans or paintbrushes or electric light bulbs of Jasper Johns, in which it is a change in context almost alone which allows us to consider them as works of art. If we did not see them mounted on a base, or in a gallery, we would hardly recognize that they have been given a character they did not formerly have. In times past, the work of art seemed to transfigure the object or the material the artist was handling; more and more today the transfiguration (when it takes place) is to the spectator, who has to shift and adjust his ideas and his conceptions as the result of sudden changes in the materials he is used to thinking of in aesthetic terms.

The introduction of objective reality into a world that has traditionally been utterly involved with suggestion and illusion is basically an effort to simplify, to purify, to cast away some of the accumulations of conventions that art has acquired over the ages. This impulse toward a new kind of simplification finds other expressions as well. It marks one of the major rejections of our times.

The simplification may find its expression in the artist's use of enormous elemental images. I am thinking of such images as the

[5] *Ibid.*

vast floating areas of almost disembodied color we encounter in the paintings of Mark Rothko (24), the big simple areas of pure paint that Ray Parker spreads so directly across his canvases, the organic shapes of Ellsworth Kelly (80). These forms seem to be reduced to their ultimate essentials. The impression they make is partly a question of scale: their very size is an important element in the mysterious power they seem to assume. Perhaps this is the hardest of all contemporary types to talk about (in this it is at the opposite end of the scale from Pop art); it is utterly nonverbal, totally lacking in literary or symbolic qualities. We accept it for what it is; and opinions, of course, are bound to differ greatly as to whether it contains enough to sustain it. But after all of the stridency, the frantic individualism, the mindless acceptance of nonartistic material, we can take a kind of satisfaction in the huge serenity of these works. The big simple image—nothing more, but enough!

Some, but not all, of the works that are characterized by such ample images are hard-edge paintings. More and more abstract painting today tends to move away from the richly intuitive involvements of the abstract expressionists and to submit itself to a discipline that becomes increasingly severe. The restriction of forms to parallel bands of sharply contrasting color, often placed against an untouched canvas background, the increasingly rigorous geometrical quality of abstract design, form a kind of straitjacket into which the artist channels his energies. The hard-edge painters, like the Pop artists, like those who deliberately cultivate anonymity, express the individual emotional disengagement characteristic of our times. Piet Mondrian, who, like Albers, was a precursor of this movement, once wrote, "The flat surface and the straight line provide the means for saying everything, but it is the artist who does the saying." The beauty of such works lies in complete clarity and perfection of proportion. They suggest an order and completeness that it is not possible to realize in the "accidental" expressions of the self, or in direct responses to the conditions of our society. They are akin to the almost inhuman geometrical perfection of some recent architec-

tural works, which contrast so dramatically with the clutter and chaos with which the uncontrolled life of the city has so often surrounded them.

Often the limitations such artists set upon themselves are extraordinarily severe. John McLaughlin divests himself of every possible association. In some cases only black and white are used, only a series of rigidly vertical forms descend across the canvas. Kenneth Noland turns the canvas on the diagonal in *Drive* and with the elegant precision of a mathematical formula moves four bands of color into place (81). Subtle and slight changes can create, even in such an austere style, individual characteristics, as in Morris Louis' *Moving In* (82), where the informality of the drips at the end of the slender columns of color create an unexpected richness.

Hard-edge design need not, of course, remain so restricted as in the examples already cited. Sven Lukin develops complex forms that seem to react one against another; his work is diagrammatic in character, its boundaries broken by rectangular forms that move into the surrounding space (34). This quality of fitting together the parts of a puzzle is quite literally present in the constructions of George Ortman, who, in *Landmark,* brings together an almost complete assembly of the repertoire of forms favored by the hard-edge painters (83): parallel bands, rectangles, arrows, hearts, crosses, and amoeba-like forms which suggest organic life.

The final stage of disengagement is reached by those painters who reject form almost totally, who limit themselves to a single color. Here there is an almost complete abandonment of richness, an utter rejection of social ideology and emotional involvement. Ad Reinhardt, both in his paintings and in his many statements, has carried this aspect of recent painting to an extreme limit (84). Although there is more formal content in his work than is initially apparent (slight differences in texture, in contrast between a glossy and a mat surface), it is clear that he has cast off all of the accumulated baggage that all previous art expressions have acquired. He accompanied one such work with the following statement:

A square (neutral, shapeless) canvas, five feet wide, five feet high, as high as a man, as wide as a man's outstretched arms (not large, not small, sizeless), trisected (no composition), one horizontal form negating one vertical form (formless, no top, no bottom, directionless), three (more or less) dark (lightless), non-contrasting (colorless) colors, brushwork brushed out to remove brushwork, a mat, flat, free-hand painted surface (glassless, textureless, non-linear, no hard edge, no soft edge) which does not reflect its surroundings— a pure, abstract, non-objective, timeless, spaceless, changeless, relationless, disinterested painting—an object that is self-conscious (no unconsciousness), ideal, transcendent, aware of no thing but art (absolutely no anti-art).[6]

The question such a statement and such a work arouses is this: after so much has been eliminated from a work of art, is enough left to make it a valid experience? Obviously Reinhardt thinks so, though human nature being what it is, one wonders whether he finds many spectators who are able to discipline themselves into a purity of vision that such works demand. I have myself heard Reinhardt's "one horizontal form negating one vertical form" interpreted quite seriously as a Christian cross and his painting consequently given a religious and symbolic meaning that must be completely foreign to the artist's intent.

Ludwig Sander produces all-blue paintings, whose one form element is a slight vertical variation in the intensity of the hue that follows down one edge of the canvas. Paul Brach, in *Riddle No. 1,* introduces the most basic and elemental of all shapes, the circle and the rectangle, but limits himself to a single color (20). As in Reinhardt, there are no linear boundaries, but slight changes in value and surface treatment define these forms, almost obscured within the enveloping whole.

So far as the public is concerned, Pop art quickly yielded to Op. This is the sort of geometrical *trompe l'oeil* that has been called optical or retinal art; it seems to stimulate the optical nerve in such a way that afterimages and color vibrations create a new perceptual activity. These phenomena have long been known and experimented with, and the results are familiar enough in textbooks on optics, but to see them now dramatically enlarged in

[6] *Ibid.,* p. 208.

scale and looked at for aesthetic rather than for demonstrative reasons is still a novelty. In one way, Op art brings the scientist and the artist closer together than any other recent movement. It is an international style, which has emerged almost simultaneously throughout western Europe and the United States; it is marked by technological accuracy and finish and consequently has appealed to those who are disturbed by the impermanent, casual quality, the accidental character, the suggested contempt of the spectator, which routine abstract expressionism and Pop art often have. Op art is serious, and it requires skill and patience. It has something of the elegance we associate with higher mathematics. Sam Hunter has truly said that such works "deceive the eye and delight the mind."

The Hungarian artist Victor Vasarely, in an ingenious series of black-and-white compositions, divides and subdivides rigidly defined geometric forms so they become mobile, so they advance and retreat in space. Their dynamic operations seem to change as we look at the work from different points of view. Richard Anuszkiewicz, in rigidly symmetrical geometric patterns, presents us with jolting color relationships that very actively set up vibrating reactions. With two contrasting colors alone, Julian Stanczak stimulates our vision so that every area of his paintings pulsates with energetic character (85). Some of the new materials have been called upon by the Op artists, such as the corrugated fiberboard Jerry Foyster uses in such a way that the dots in his compositions shift and readjust themselves as we pass before his work (86). The enormous wheels of banded color by Tadasky start to spin before our eyes (87). All of this is another, and a very positive, way of drawing the spectator into the total aesthetic experience, this time in an almost purely physical way. Though it is created by mental discipline and technical skill, its final aesthetic effect is a triumph of matter over mind.

Every one of the movements suggested here is, in one way or another, a revolt against some established earlier form or method. Has everything been rejected? Is there anything to revolt against any more? It is now almost impossible to cause an out-

rage in the world of art. Even obscenity, which was once the final limit, is no longer an absolute.

But of course it *is* always possible to find something more to reject, and art is by no means the only field in which a return to what we have long considered conservatism offers an alluring possibility. The unlimited freedom of self-expression, the boundless opportunities for artistic experimentation, the self-conscious disregard of social responsibilities which the artist, as a free agent, has long enjoyed, can themselves begin to seem limiting factors. The rejection of abstract artistic activities has led certain artists to a return to some of the very qualities which, for a generation, have been either avoided or considered hopelessly outworn.

The work of a number of recent artists shows us that it is still possible to use long-established traditions with freshness, individuality, and intelligence. It is true that such a statue as David Aronson's *High Priest* suggests ancient ritual objects (88); it is not only a work of great formal distinction, but also a highly personal expression. It echoes a tradition; we can hardly look at it without thinking of it in terms of a long succession of ideas and forms. Morris Broderson's *Battle of the Giants,* like medieval or Renaissance works, has an elaborate and complicated iconography (89), and while it certainly stands on its own feet as a formal creation, it cannot be completely understood unless we are aware of its several levels of meaning: Moby Dick, the Kabuki drama, the hand language of the deaf, the symbolic confining ropes of fate. Is it wrong still to compose works that must be "read" in this way? Not if the artist thinks and feels in terms that make this appropriate and is able to keep all of the elements in his creation in workable relationships.

Purely abstract works can mark a return to tradition as well. This is particularly to be seen in the work of some of the younger Japanese painters who have come to this country and who are playing an increasingly important role here. Masatoyo Kishi's *Opus No. 62–607* (90), for all of its relationships with American abstract expressionism, remains astonishingly close to ancient oriental traditions, in color, composition, and handling of

the material. Sometimes the youthful traditionalist turns specifically to earlier works of art as source material but in a way utterly unlike the method by which the influence of one artist to another was transmitted in the past. We encounter the curious motif of representations of works of art in works of art: one thinks of George Deem's poetic and nostalgic translations of prints and pictures of the past (91). The landscape in his *February 1964* is not the reflection of an actual landscape, but a painting of an old-fashioned calendar, suggesting serene joys and patriotic virtues that have long been avoided. This may be another expression of the feeling that works of art are simply objects, like all other objects, and consequently just as available as are natural forms as sources for individual artistic expression.

We note, also, the emergence of figure painting that can only be related to the academic art of the past. It has been interesting to observe the reaction of other artists to the recent figure paintings of Philip Pearlstein (92); older painters tended to dismiss his work as hopelessly reactionary, while younger artists, largely brought up in the atmosphere of abstract expressionism or in the discipline of geometrical abstraction, found such work excitingly novel. Pearlstein's departures from academic painting (in composition and in lighting) were not sufficiently recognized by the former, while it may have been in part sheer ignorance that led some of the younger artists to their enthusiastic response.

Here the story breaks off in midstream. Nothing has come to an end; we can only be sure that artists will emerge in the future who will respond in ways still different from those suggested here. Paul Tillich once wrote: "Modern art is not propaganda but revelation. It shows that the reality of our existence is as it is. It does not cover up the reality in which we are living."[7] The joys and sorrows of recent American art are the joys and sorrows of the society, the total culture, of which we are a part. Its study is not only analysis, but also self-examination.

[7] Paul Tillich, *The Courage to Be* (New Haven: Yale University Press, 1952), p. 147.

List of Illustrations

1 Richard Stankiewicz, *Kabuki Dancer,* 1956, steel and cast iron, 80¼″ high, New York, Whitney Museum of American Art, gift of The Friends of the Whitney Museum.

2 Lee Bontecou, *Untitled,* 1962, welded steel and canvas, 75″ x 83″ x 28″, Bascl, Kunstmuseum, Depositum der Emanuel Hoffmann-Stiftung.

3 Andy Warhol, *Jackie,* 1964, acrylic and silkscreen on canvas, nine panels, 26″ x 16″ each panel, courtesy of Leo Castelli Gallery, New York.

4 Robert Indiana, *Louisiana,* 1966, oil on canvas, 70″ x 60″, Champaign, Illinois, Krannert Art Museum, University of Illinois.

5 Willem De Kooning, *Woman I,* 1950–51, oil on canvas, 75⅞″ x 58″, New York, The Museum of Modern Art.

6 Roy Lichtenstein, *Live Ammo: Blang,* 1962, oil on canvas, 68″ x 80″, Thousand Oaks, California, Mr. Edwin Janss, Jr.

7 Jack Youngerman, *Fulton,* 1963, oil on canvas, 73½″ x 63″, Richmond, Virginia, Mr. and Mrs. Sydney Lewis.

8 Rico Lebrun, *Dying Steer,* 1958, casein and oil glazes on paper of plywood, 42″ x 71½″, Champaign, Illinois, Krannert Art Museum, University of Illinois.

9 Jack Zajac, *Easter Goat No. 4,* 1960, bronze, 24″ high, Winnetka, Illinois, Mr. and Mrs. Jay A. Pritzker.

10 Abraham Rattner, *Figure and Mask,* 1948, oil on canvas, 36¼″ x 28¾″, Champaign, Illinois, Krannert Art Museum, University of Illinois.

11 William Zorach, *Contemplation,* 1962, granite, 13″ high, courtesy of The Downtown Gallery, New York.

12 Harold Tovish, *The Blind Man,* 1955, bronze, 8″ high, Cambridge, Massachusetts, Mr. Robert G. Gardner.

13 Claes Oldenburg, *Shirt on Chair with Wallet and Other Objects,* 1962, plaster on wire painted with enamel, wood, stuffed and

84

61 Larry Rivers, *Dead and Dying Veteran,* 1961, oil on canvas, 70″ x 94″, Chestnut Hill, Massachusetts, Mr. Max Wasserman.

62 Llyn Foulkes, *Post Card No. 2,* 1964, oil on canvas, 63 7/16″ x 62 7/16″, Bellevue, Washington, Mr. and Mrs. John C. Denman.

63 Robert Courtright, *Untitled,* 1964, cloth collage on wood, 38″ x 30″, courtesy of Richard Feigen Gallery, New York and Chicago.

64 Richard Lippold, *Variation No. 7: Full Moon,* 1949–50, brass rods, nickel-chromium stainless steel wire, 10′ high, New York, The Museum of Modern Art, Simon Guggenheim Fund.

65 Calvin Albert, *Outer World,* 1964, pewter alloy, 63½″ x 46″ x 40″, courtesy of Stable Gallery, New York.

66 Frank Gallo, *The Swimmer,* 1964, polyester resin, 65″ x 16″, New York, Whitney Museum of American Art.

67 Paul Jenkins, *Phenomena Point Swing and Flank,* 1964, acrylic on canvas, 71¾″ x 115½″, Champaign, Illinois, Krannert Art Museum, University of Illinois.

68 Robert Rauschenberg, *Curfew,* 1958, combine painting, 56½″ x 39½″, New York, Mr. and Mrs. Ben Heller.

69 Marisol, *The Bathers,* 1961–62, wood and mixed mediums, 84″ x 70½″, New York, Mr. William A. M. Burden.

70 Alvin Light, *May,* 1962, hardwoods, 58½″ x 73″ x 35″, The Art Institute of Chicago.

71 Robert Mallary, *Lot's Wife,* 1961–62, cement, iron, and wood, 33″ x 26″, courtesy of Allan Stone Gallery, New York.

72 Salvatore Scarpitta, *Sundial for Racing,* 1962, canvas relief, 89¾″ x 72½″, Champaign, Illinois, Krannert Art Museum, University of Illinois.

73 Charles Frazier, *Object of Affection,* 1964, bronze, 12″ diameter, Los Angeles, Mr. William C. Kuhns.

74 Thomas Akawie, *Dr. Strangelove,* 1964, enamel on canvas, 36″ x 34″, courtesy of Comara Gallery, Los Angeles.

75 H. C. Westermann, *The Big Change,* 1963, laminated plywood, 56″ high, New York, Mr. and Mrs. William Copley.

76 James Rosenquist, *Painting for the American Negro,* 1962–63, oil on canvas (three panels), 80″ x 210″, Ottawa, The National Gallery of Canada.

77 Wayne Thiebaud, *Two Sitting Figures,* 1965, oil on canvas, 60″ x 72″, collection of the artist.

78 Peter Saul, *Ice Box No. 6,* 1963, oil on canvas, 75½″ x 63″, Chicago, Mr. Lewis Manilow.

Plates

Plate 1

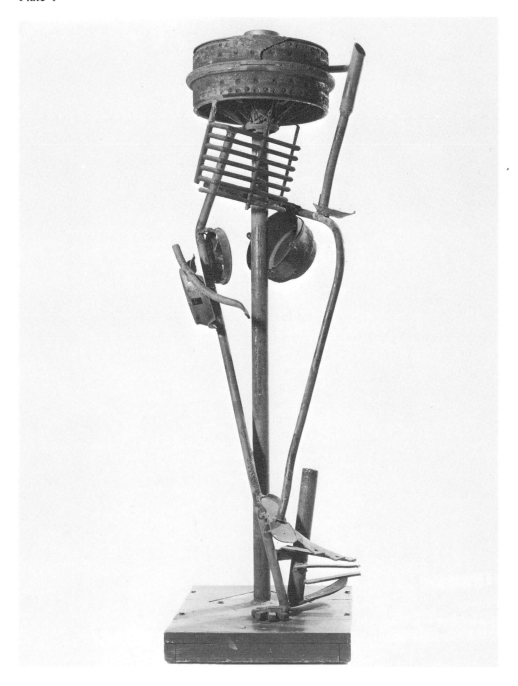

RICHARD STANKIEWICZ: *Kabuki Dancer* (1956). New York, Whitney Museum of American Art.

Plate 2

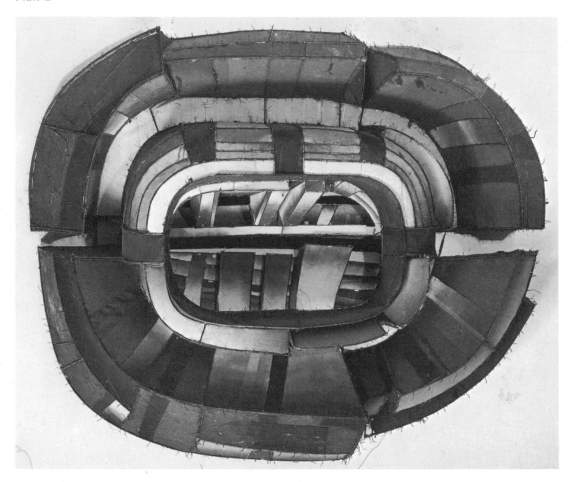

LEE BONTECOU: *Untitled* (1962). Basel, Kunstmuseum.

Plate 3

ANDY WARHOL: *Jackie* (1964). Courtesy of Leo Castelli Gallery, New York.

Plate 4

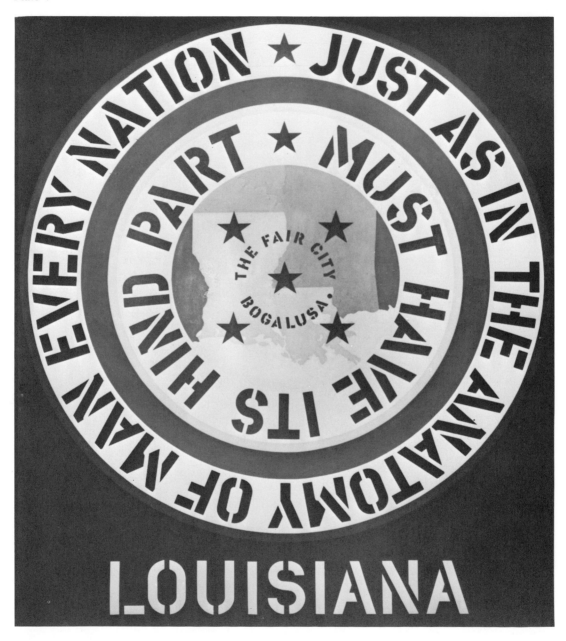

ROBERT INDIANA: *Louisiana* (1966). Champaign, Krannert Art Museum, University of Illinois.

Plate 5

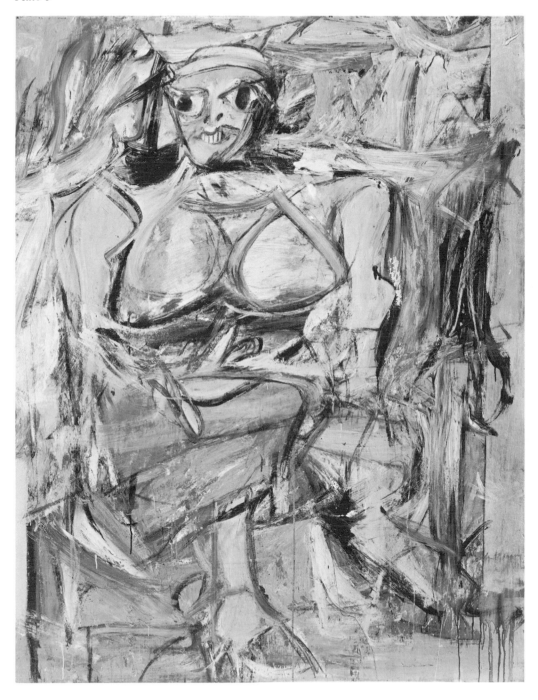

WILLEM DE KOONING: *Woman I* (1950–51). New York, The Museum of Modern Art.

Plate 6

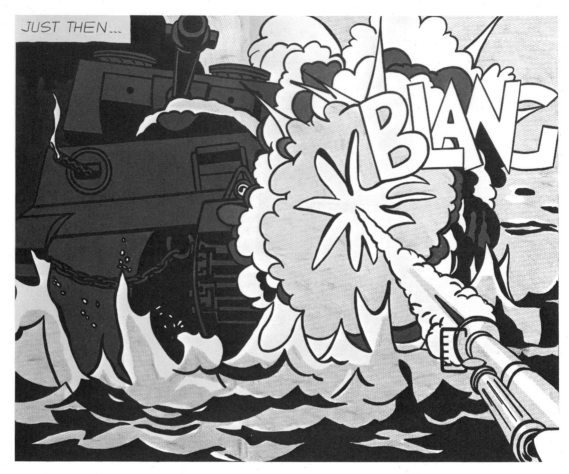

ROY LICHTENSTEIN: *Live Ammo: Blang* (1962). Thousand Oaks, California, Mr. Edwin Janss, Jr.

Plate 7

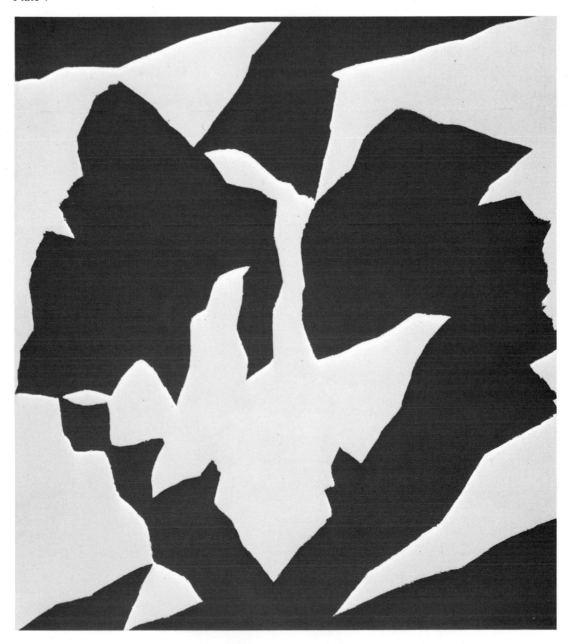

JACK YOUNGERMAN: *Fulton* (1963). Richmond, Virginia, Mr. and Mrs. Sydney Lewis.

Plate 8

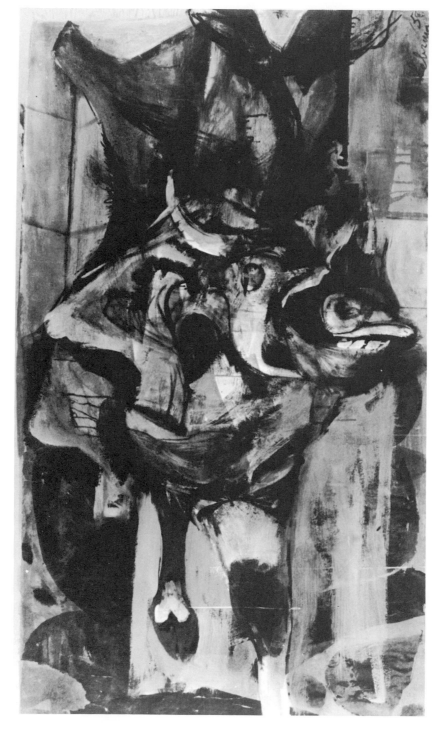

RICO LEBRUN: *Dying Steer* (1958). Champaign, Krannert Art Museum, University of Illinois.

Plate 9

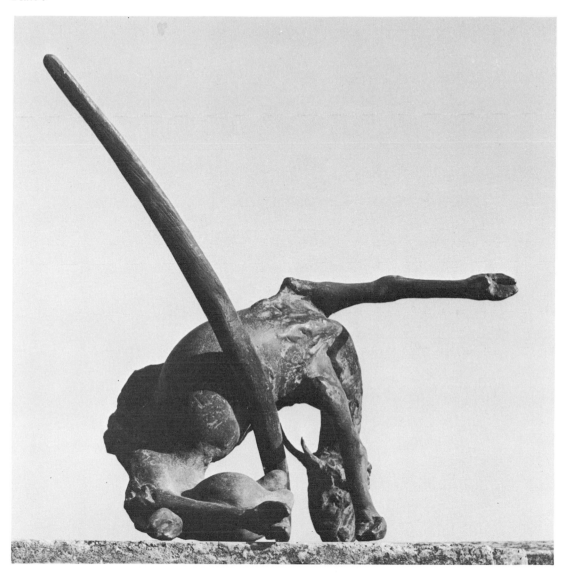

JACK ZAJAC: *Easter Goat No. 4* (1960). Winnetka, Illinois, Mr. and Mrs. Jay A. Pritzker.

Plate 10

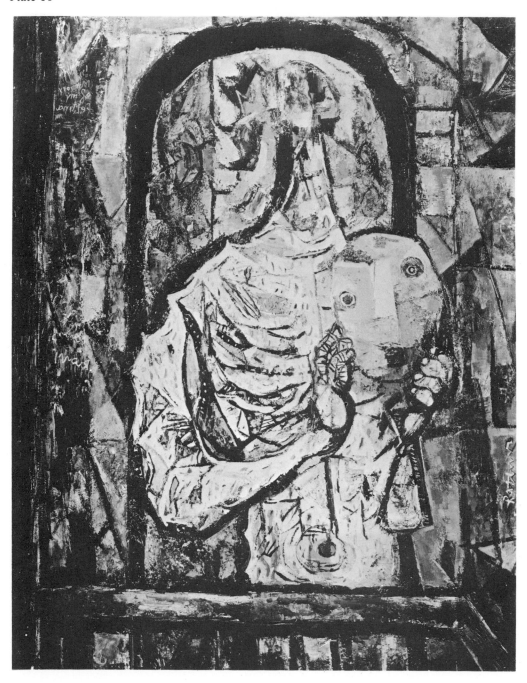

ABRAHAM RATTNER: *Figure and Mask* (1948). Champaign, Krannert Art Museum, University of Illinois.

Plate 11

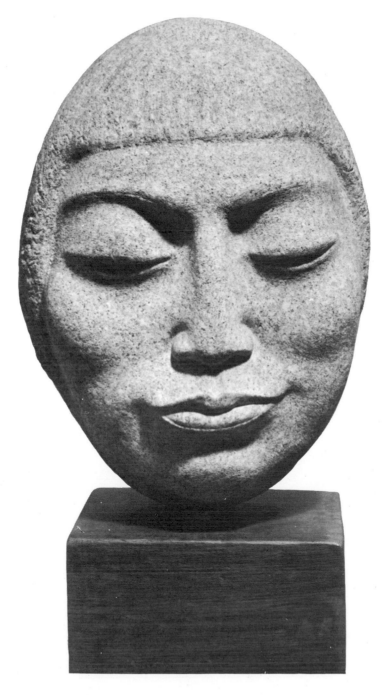

WILLIAM ZORACH: *Contemplation* (1962).
Courtesy of The Downtown Gallery, New York.

Plate 12

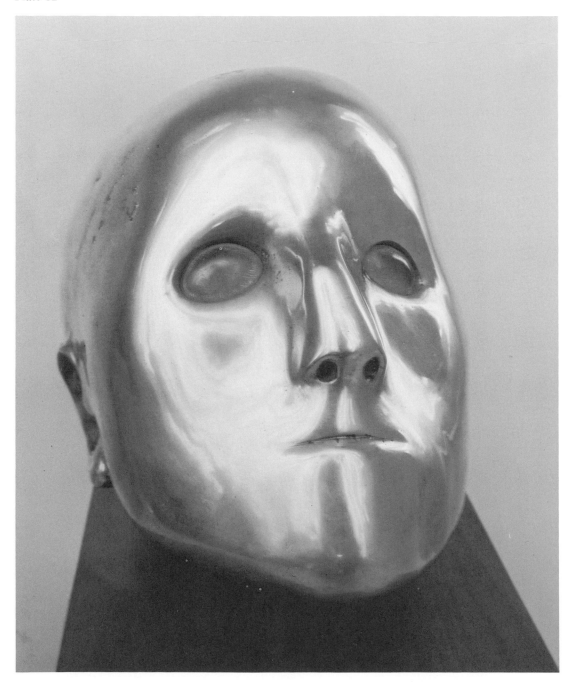

HAROLD TOVISH: *The Blind Man* (1955). Cambridge, Massachusetts, Mr. Robert G. Gardner.

Plate 13

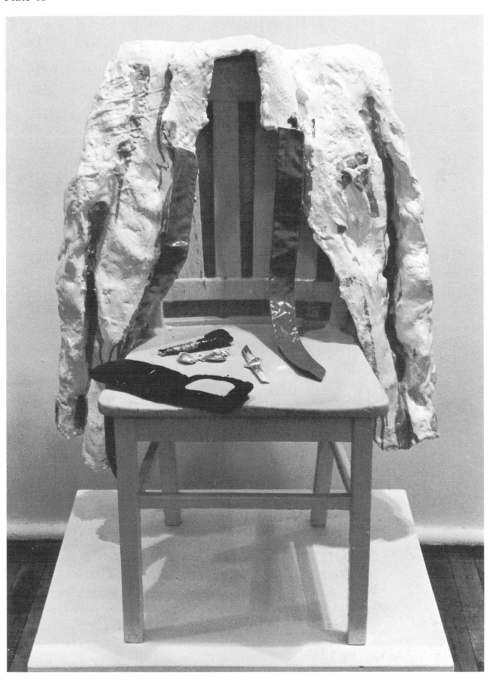

CLAES OLDENBURG: *Shirt on Chair with Wallet and Other Objects* (1962). Varese, Italy, Count Panza di Biumo.

Plate 14

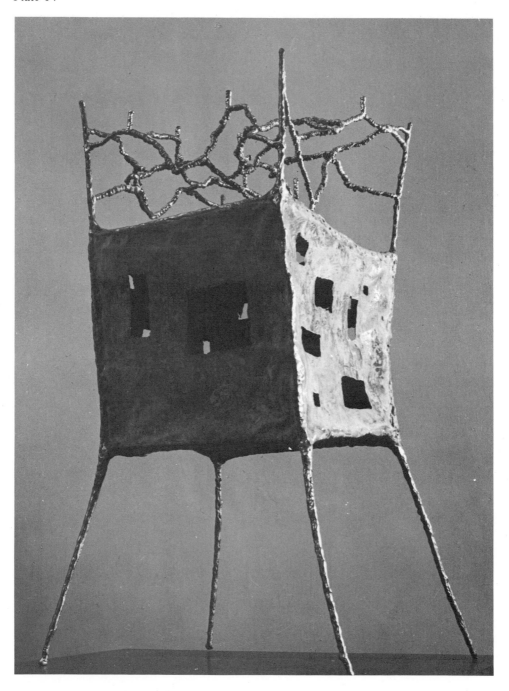

IBRAM LASSAW: *Zodiac House* (1958). Courtesy of Staempfli Gallery, New York.

Plate 15

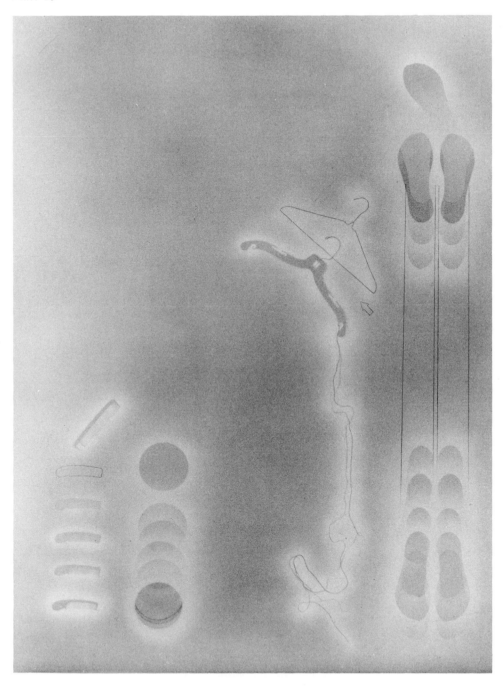

ARAKAWA: *Untitled* (1963). Courtesy of Dwan Gallery, New York.

Plate 16

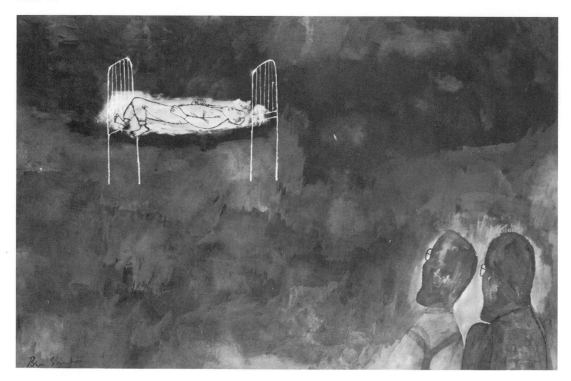

BEN SHAHN: *It's No Use to Do Anymore* (1961–62). Lynchburg, Virginia, Randolph-Macon Women's College.

Plate 17

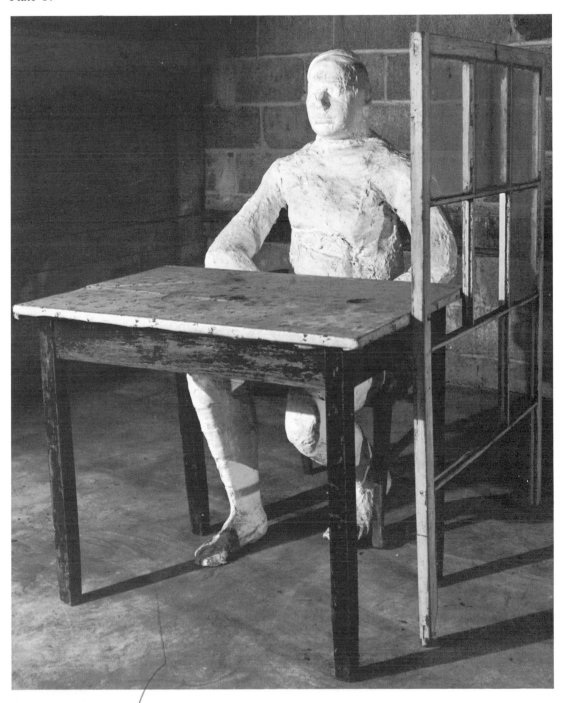

GEORGE SEGAL: *Seated Man at Table* (1961). Courtesy of Sidney Janis Gallery, New York.

Plate 18

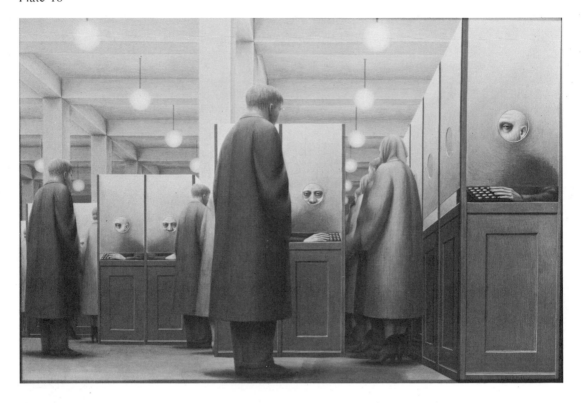

GEORGE TOOKER: *Government Bureau* (1956). New York, The Metropolitan Museum of Art.

Plate 19

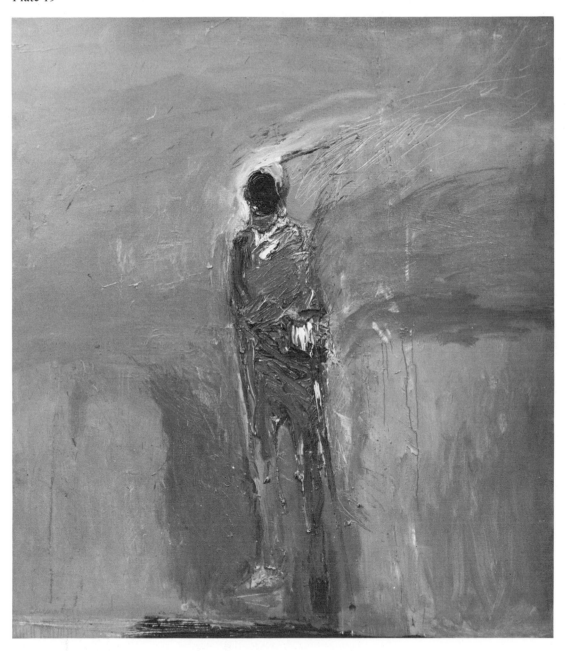

NATHAN OLIVEIRA: *Standing Man with a Stick* (1959). New York, The Museum of Modern Art.

Plate 20

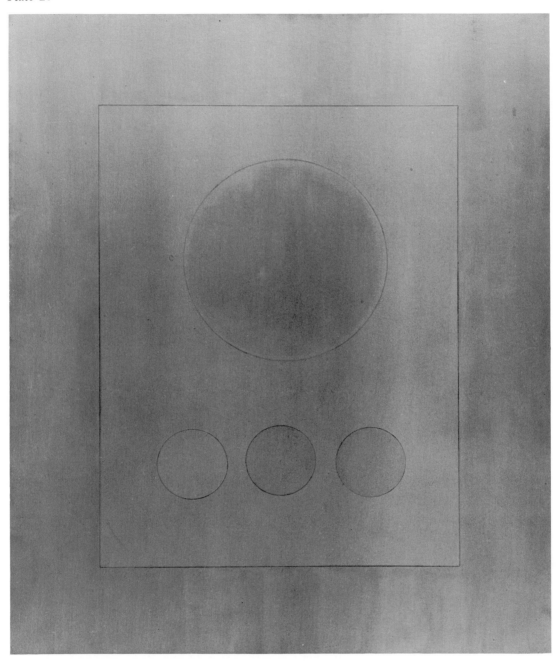

PAUL BRACH: *Riddle No. 1* (1961). Collection of the artist.

Plate 21

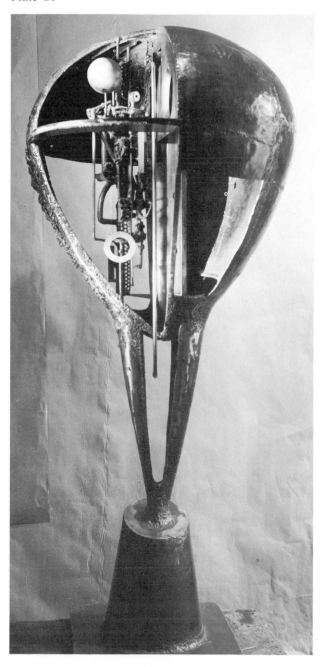

THEODORE ROSZAK: *Explorer No. 2* (1962). Collection of the artist.

Plate 22

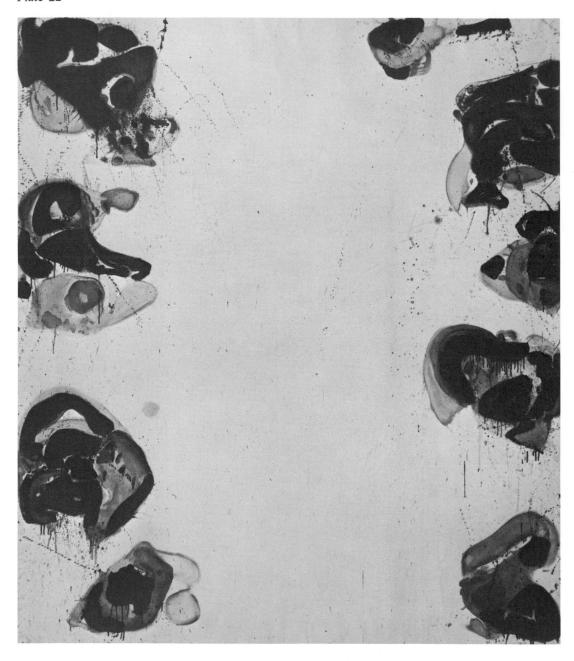

SAM FRANCIS: *Blue Balls* (1960). Washington, Smithsonian Institution.

Plate 23

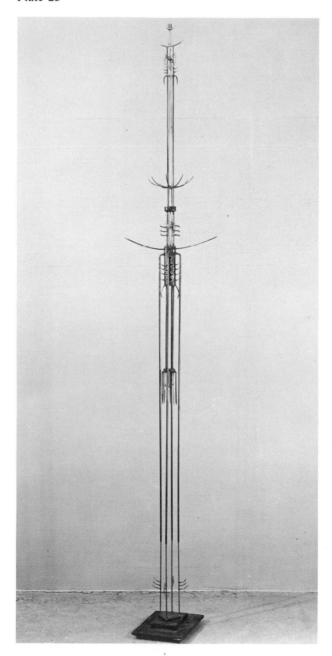

JOSEPH GOTO: *Organic Form No. 1* (1951). New York, The Museum of Modern Art.

Plate 24

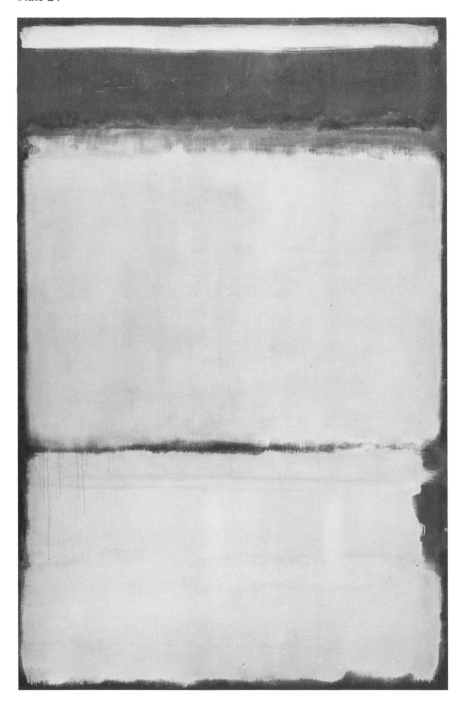

MARK ROTHKO: *Number 10* (1950). New York, The Museum of Modern
Art.

Plate 25

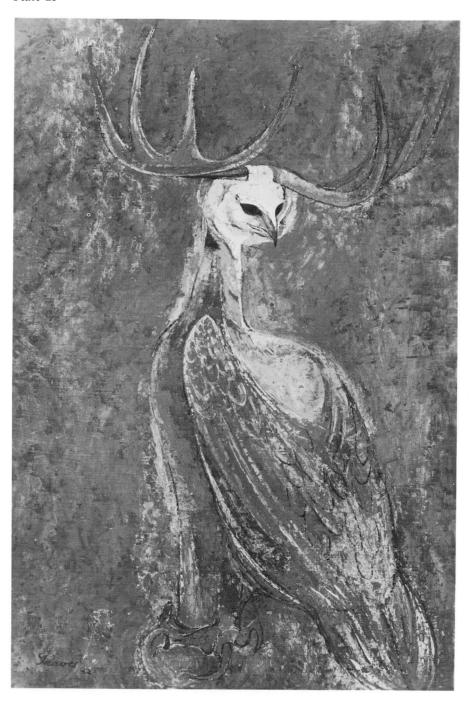

MORRIS GRAVES: *Guardian* (1952). Champaign, Krannert Art Museum, University of Illinois.

Plate 26

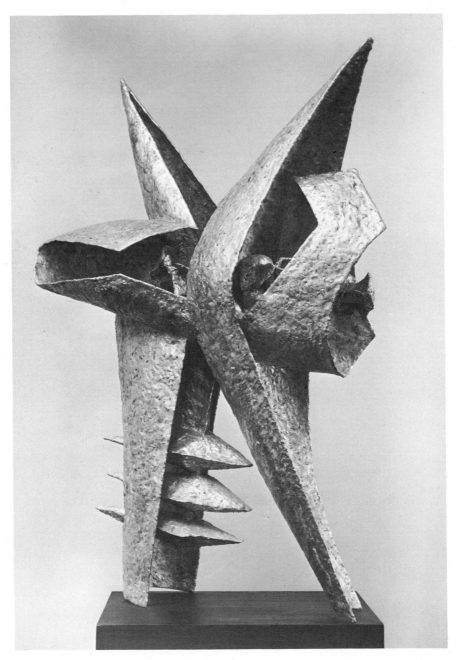

SEYMOUR LIPTON: *Knight* (1957). New York, Mr. Howard Lipton.

Plate 27

WILLIAM BAZIOTES: *Dwarf* (1947). New York, The Museum of Modern Art.

Plate 28

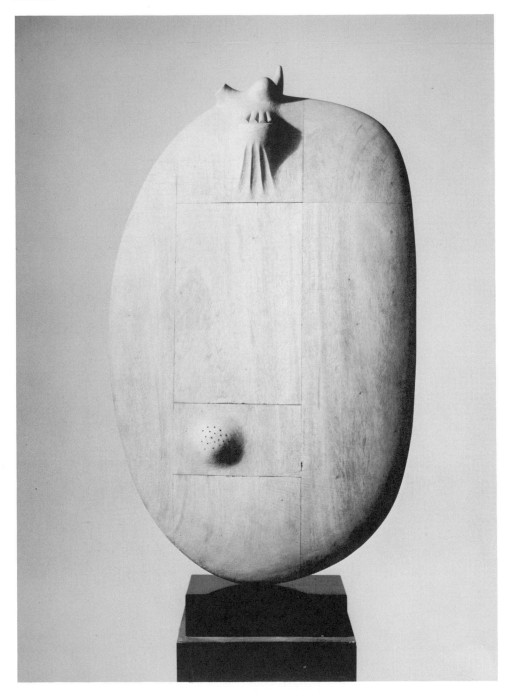

JACK SQUIER: *Blind Animal* (1962). Courtesy of Landau-Alan Gallery, New York.

Plate 29

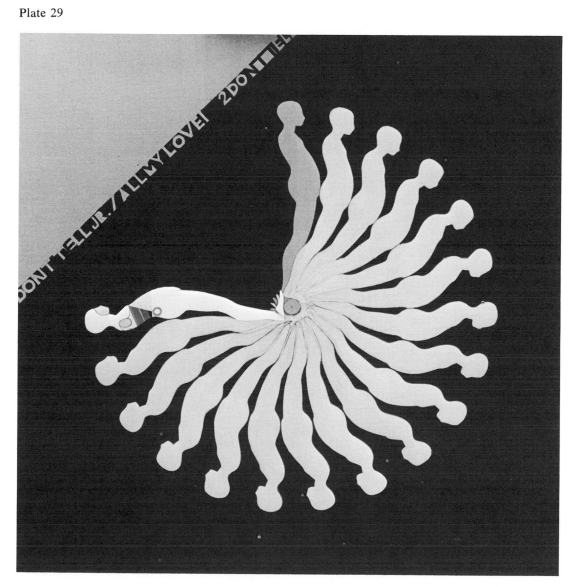

ERNEST TROVA: *Study, Falling Man, No. 77* (1963). Brooklyn, Mr. and Mrs. Hollis K. Thayer.

Plate 30

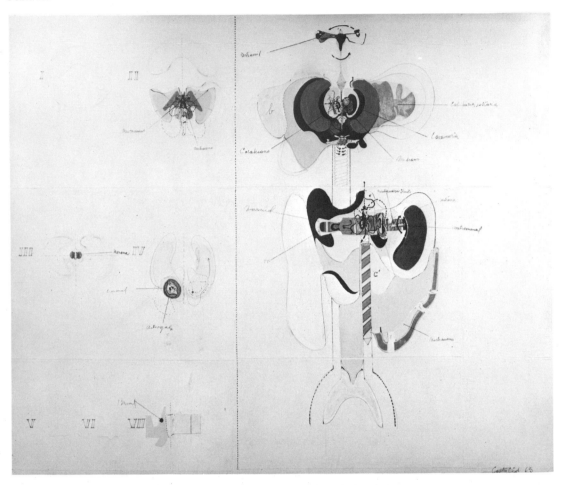

ENRIQUE CASTRO-CID: *Sylvia's Invention* (1963). Courtesy of Richard Feigen Gallery, New York and Chicago.

Plate 31

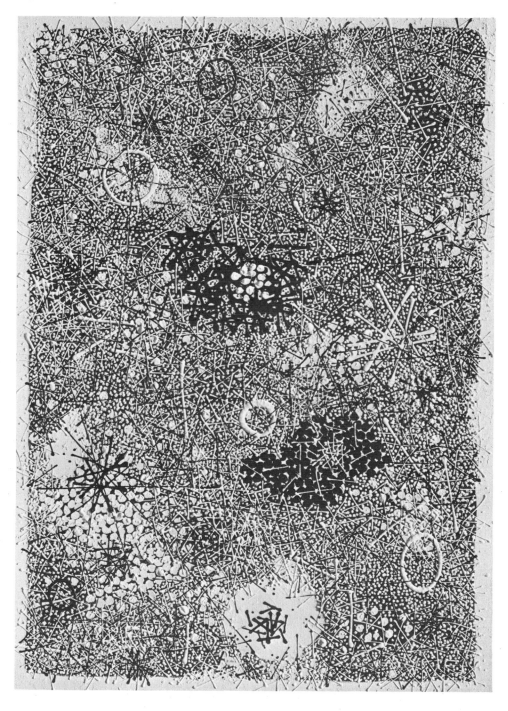

GORDON ONSLOW-FORD: *Who Lives* (1962). New York, Whitney Museum of American Art.

Plate 32

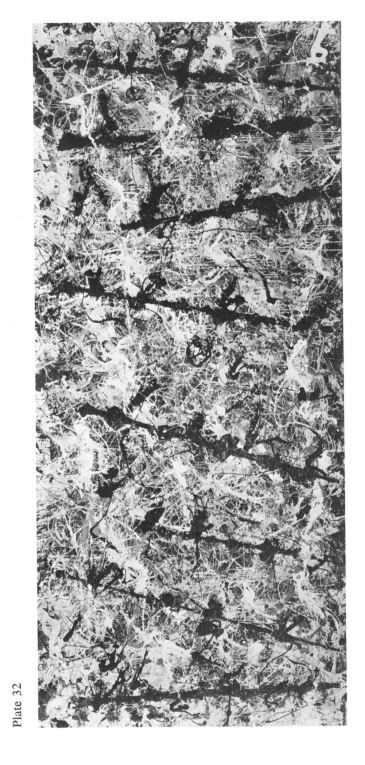

JACKSON POLLOCK: *Blue Poles, No. 11* (1952). New York, Mr. and Mrs. Ben Heller.

Plate 33

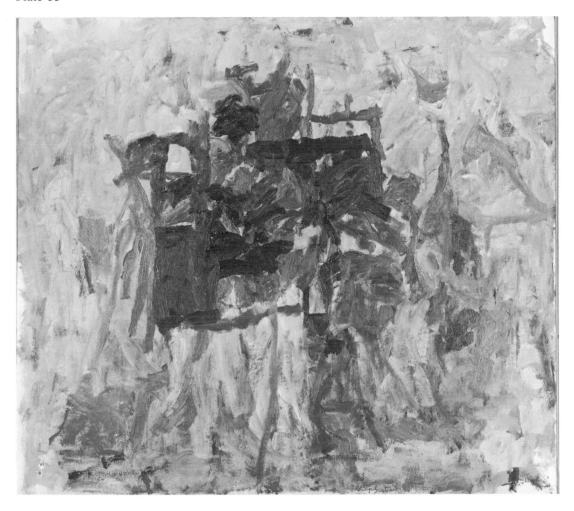

PHILIP GUSTON: *Sleeper I* (1958). The Cleveland Museum of Art.

Plate 34

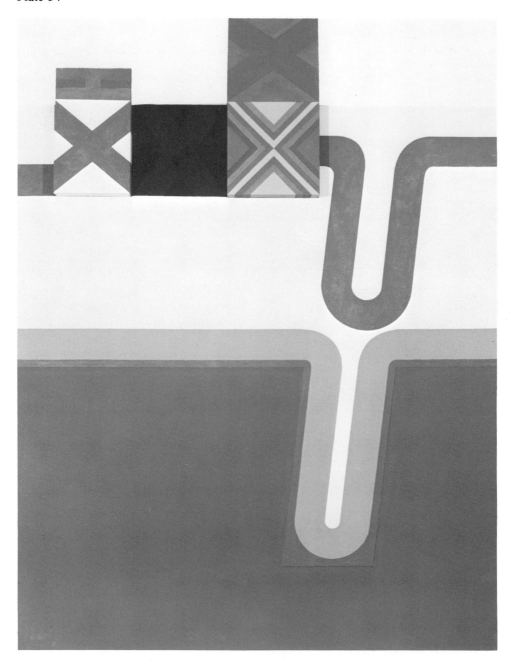

SVEN LUKIN: *Birthday Painting* (1964). Courtesy of Pace Gallery, New York.

Plate 35

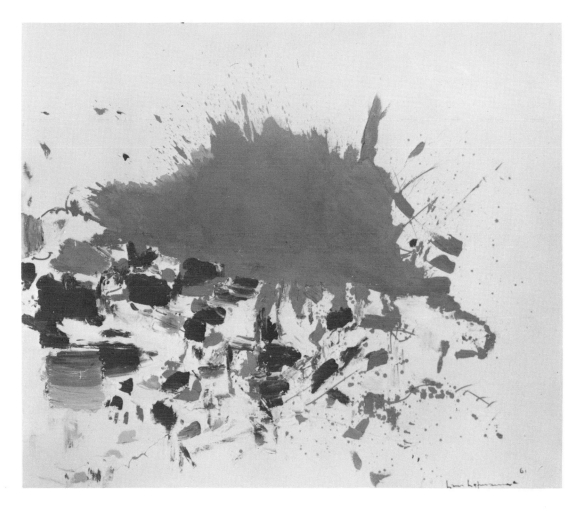

HANS HOFMANN: *Scattered Sunset* (1961). Courtesy of Samuel M. Kootz Gallery, New York.

Plate 36

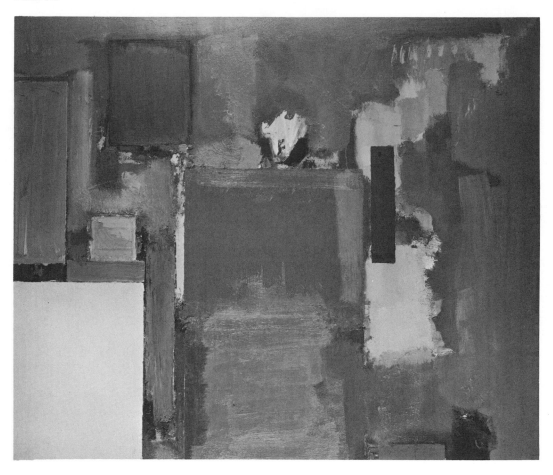

HANS HOFMANN: *The Golden Wall* (1961). The Art Institute of Chicago.

Plate 37

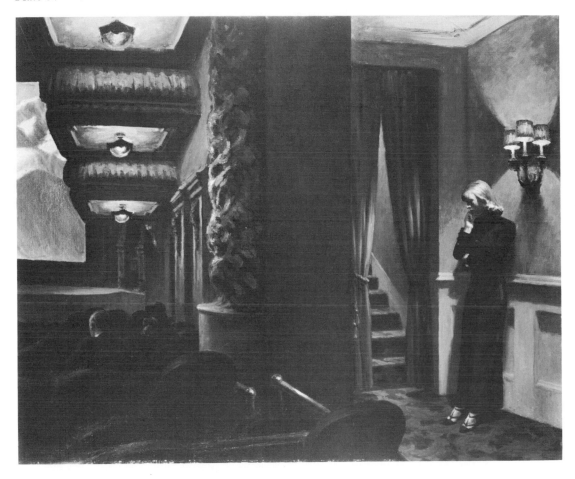

EDWARD HOPPER: *New York Movie* (1939). New York, The Museum of Modern Art.

Plate 38

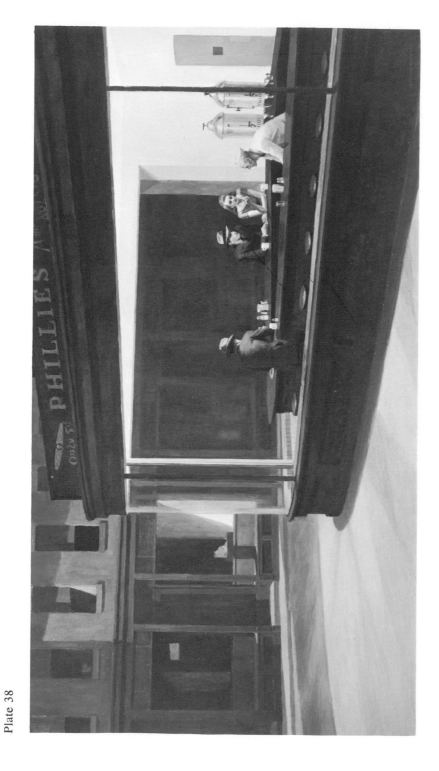

EDWARD HOPPER: *Nighthawks* (1942). The Art Institute of Chicago.

Plate 39

GEORGIA O'KEEFFE: *Black Cross, New Mexico* (1929). The Art Institute of Chicago.

Plate 40

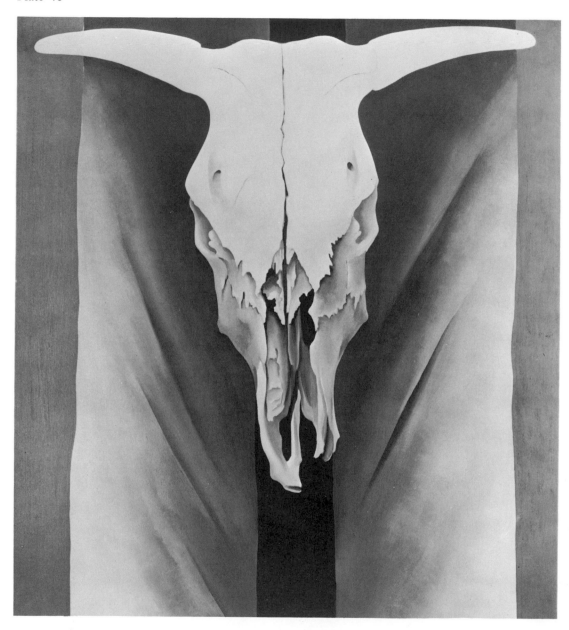

GEORGIA O'KEEFFE: *Cow's Skull: Red, White, and Blue* (1931). New York, The Metropolitan Museum of Art.

Plate 41

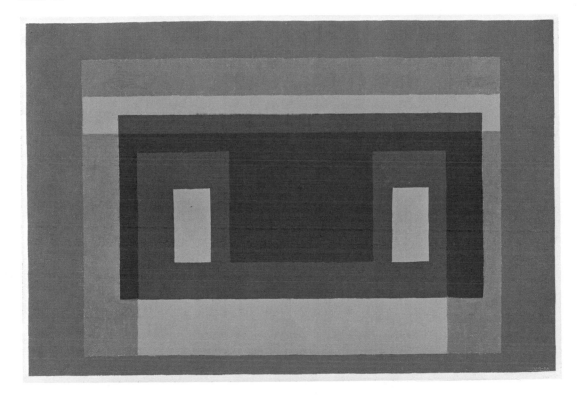

JOSEF ALBERS: *Inside and Out* (1948–53). Hartford, Connecticut, Wadsworth Atheneum.

Plate 42

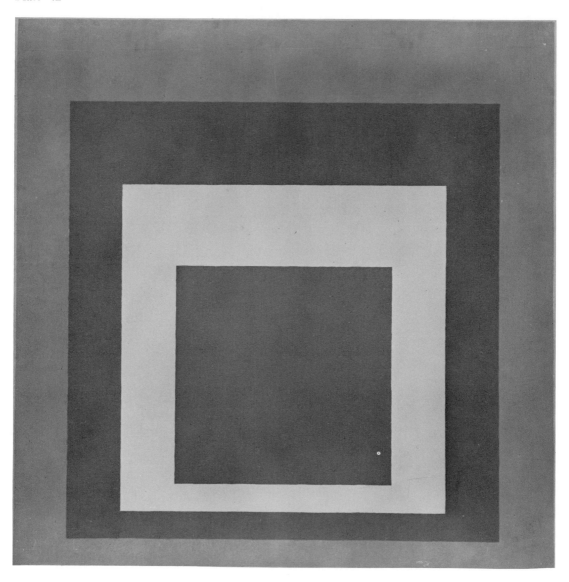

JOSEF ALBERS: *Homage to the Square: Ascending* (1953). New York, Whitney Museum of American Art.

Plate 43

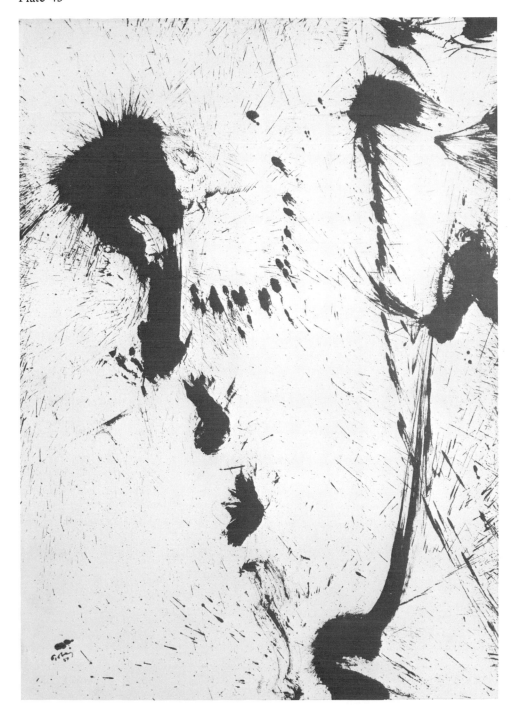

MARK TOBEY: *Space Ritual No. 7* (1957). Collection of the artist.

Plate 44

MARK TOBEY: *New York Tablet* (1946). Utica, New York, Munson-Williams-Proctor Institute.

Plate 45

CHARLES BURCHFIELD: *The Four Seasons* (1949–60). Champaign, Krannert Art Museum, University of Illinois.

Plate 46

CHARLES BURCHFIELD: *Orion in December* (1959). Washington, Smithsonian Institution.

Plate 47

STUART DAVIS: *Owh! In San Paó* (1951). New York, Whitney Museum of American Art.

Plate 48

STUART DAVIS: *General Studies* (1962). Champaign, Krannert Art Museum, University of Illinois.

Plate 49

ABRAHAM RATTNER: *Window Cleaner No. 3* (1951). Urbana, Illinois, Mr. and Mrs. Allen S. Weller.

Plate 50

IVAN ALBRIGHT: *Into the World There Came a Soul Called Ida* (1929–30). Collection of the artist.

Plate 51

IVAN ALBRIGHT: *Head of Adam Emory Albright* (1935). Champaign, Krannert Art Museum, University of Illinois.

Plate 52

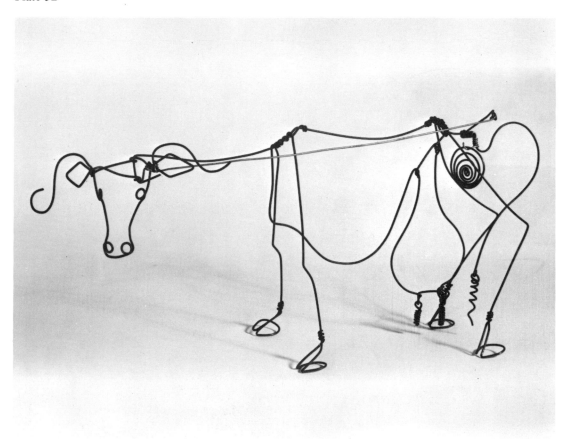

ALEXANDER CALDER: *Cow* (1929). New York, The Museum of Modern Art.

Plate 53

ALEXANDER CALDER: *Clouds Over Mountains* (1962). The Art Institute of Chicago.

Plate 54

SAMUEL ADLER: *Mauve Still Life* (1951). Champaign, Krannert Art Museum, University of Illinois.

Plate 55

SAMUEL ADLER: *Composition with Five Figures* (1966). Collection of the artist.

Plate 56

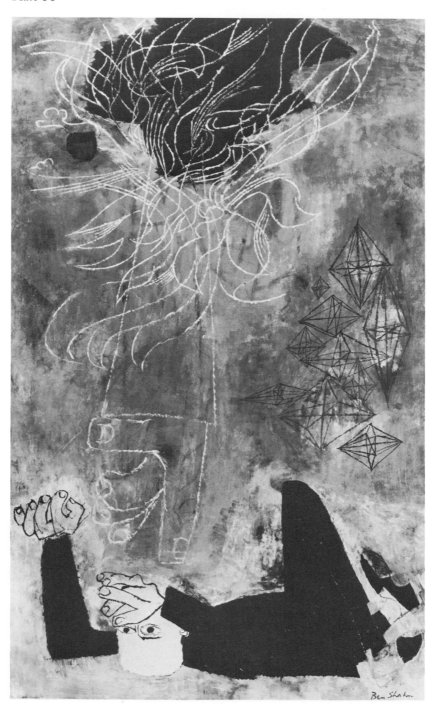

BEN SHAHN: *Second Allegory* (1952). Champaign, Krannert Art Museum, University of Illinois.

Plate 57

BRADLEY WALKER TOMLIN: *Number 1—1949* (1949).
New York, Mrs. Ethel K. Schwabacher.

Plate 58

ARSHILE GORKY: *The Liver Is the Cock's Comb* (1944). Buffalo, New York, Albright-Knox Gallery.

Plate 59

FRANZ KLINE: *Painting No. 7* (1952). New York, The Solomon R. Guggenheim Museum.

Plate 60

ELIAS FRIEDENSOHN: *The Secret* (1962). Los Angeles, Mr. Marvin David Miller.

Plate 61

LARRY RIVERS: *Dead and Dying Veteran* (1961). Chestnut Hill, Massachusetts, Mr. Max Wasserman.

Plate 62

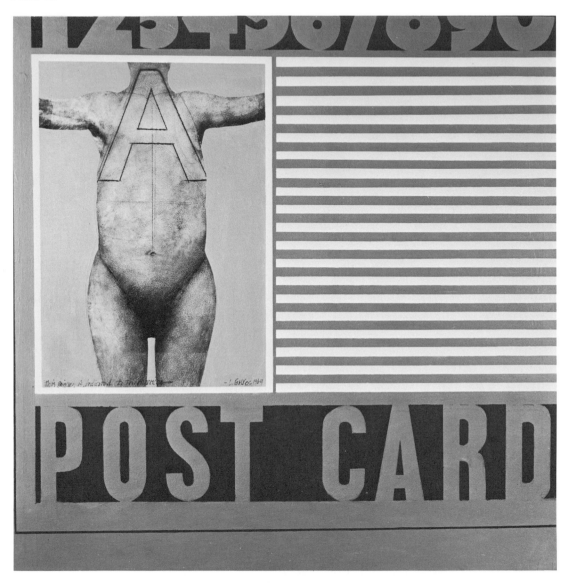

LLYN FOULKES: *Post Card No. 2* (1964). Bellevue, Washington, Mr. and Mrs. John C. Denman.

Plate 63

ROBERT COURTRIGHT: *Untitled* (1964). Courtesy of Richard Feigen Gallery, New York and Chicago.

Plate 64

RICHARD LIPPOLD: *Variation No. 7: Full Moon* (1949–50). New York, The Museum of Modern Art.

Plate 65

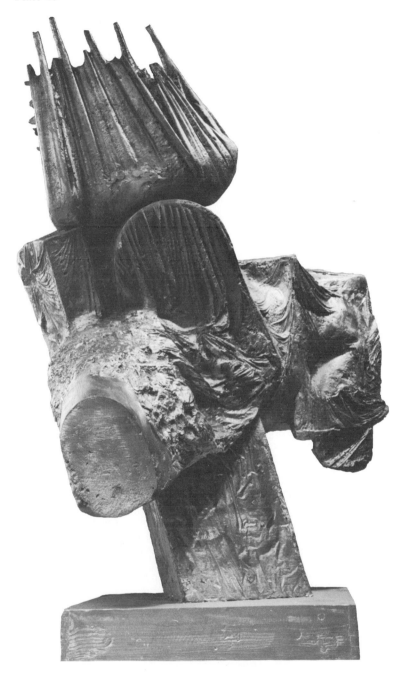

CALVIN ALBERT: *Outer World* (1964). Courtesy of Stable Gallery,
New York.

Plate 66

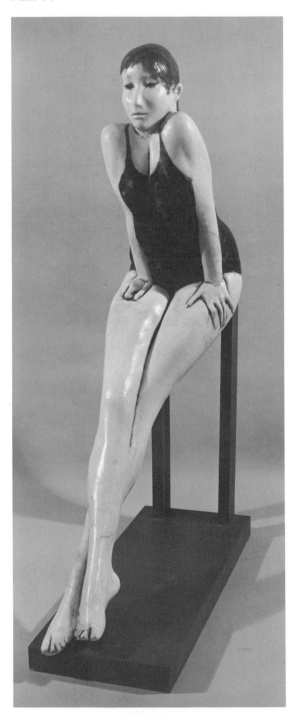

FRANK GALLO: *The Swimmer* (1964). New York, Whitney Museum of American Art.

Plate 67

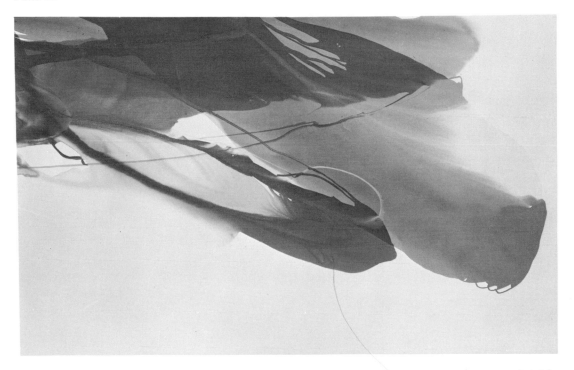

PAUL JENKINS: *Phenomena Point Swing and Flank* (1964). Champaign, Krannert Art Museum, University of Illinois.

Plate 68

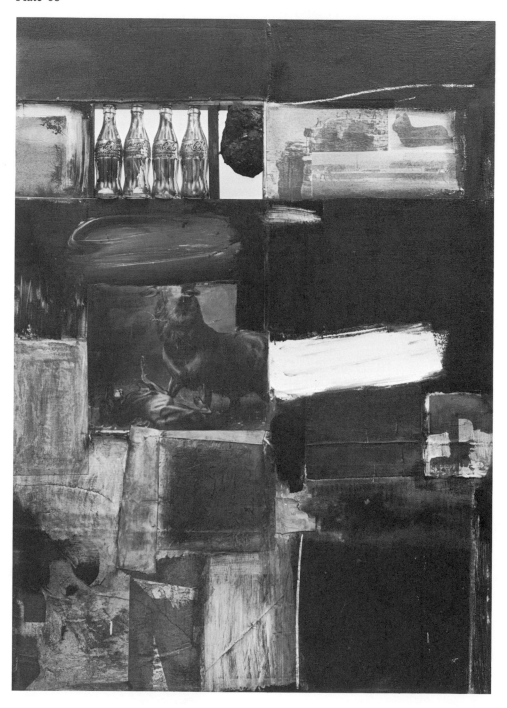

ROBERT RAUSCHENBERG: *Curfew* (1958). New York, Mr. and Mrs. Ben Heller.

Plate 69

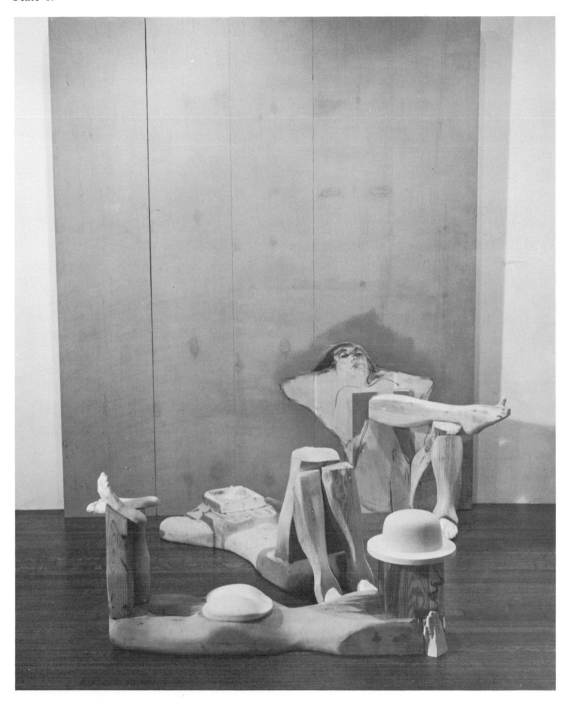

MARISOL: *The Bathers* (1961–62). New York, Mr. William A. M. Burden.

Plate 70

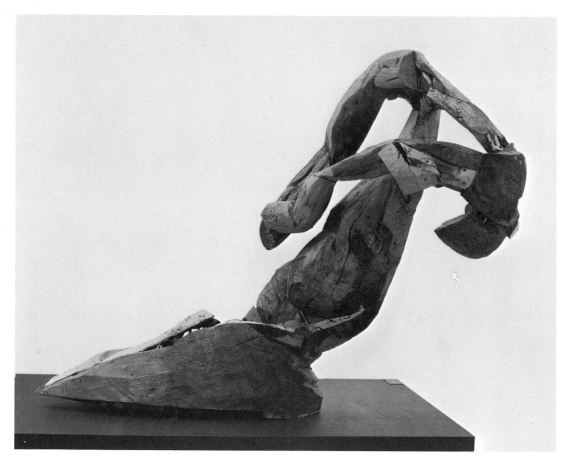

ALVIN LIGHT: *May* (1962). The Art Institute of Chicago.

Plate 71

ROBERT MALLARY: *Lot's Wife* (1961–62). Courtesy of Allan Stone Gallery, New York.

Plate 72

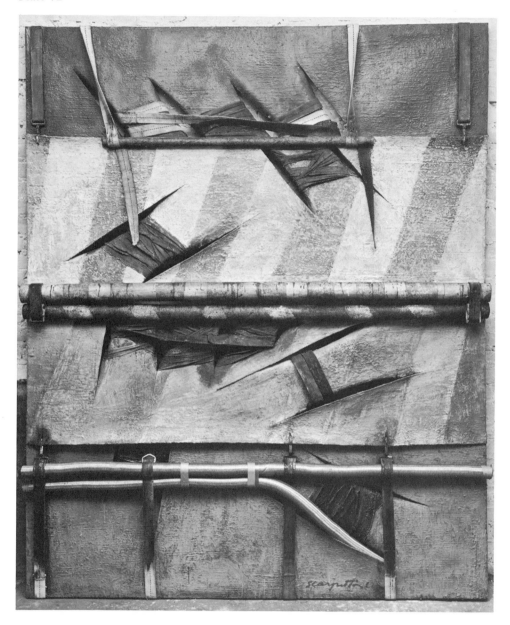

SALVATORE SCARPITTA: *Sundial for Racing* (1962). Champaign, Krannert Art Museum, University of Illinois.

Plate 73

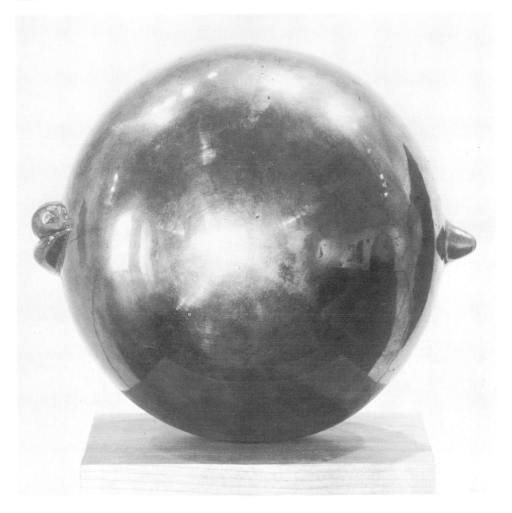

CHARLES FRAZIER: *Object of Affection* (1964). Los Angeles, Mr. William C. Kuhns.

Plate 74

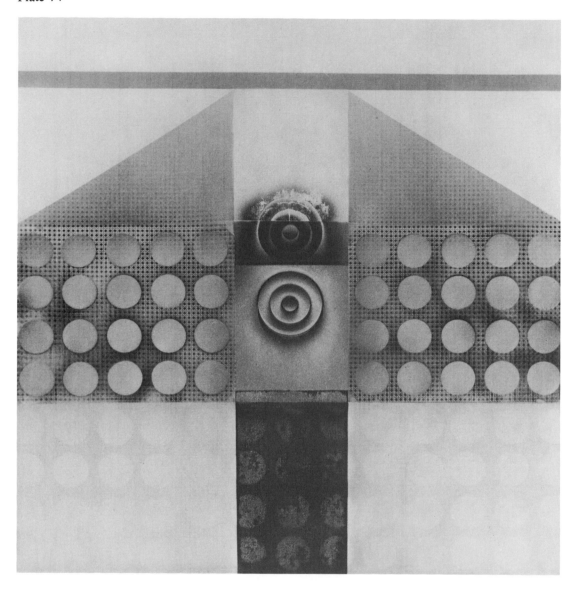

THOMAS AKAWIE: *Dr. Strangelove* (1964). Courtesy of Comara Gallery, Los Angeles.

Plate 75

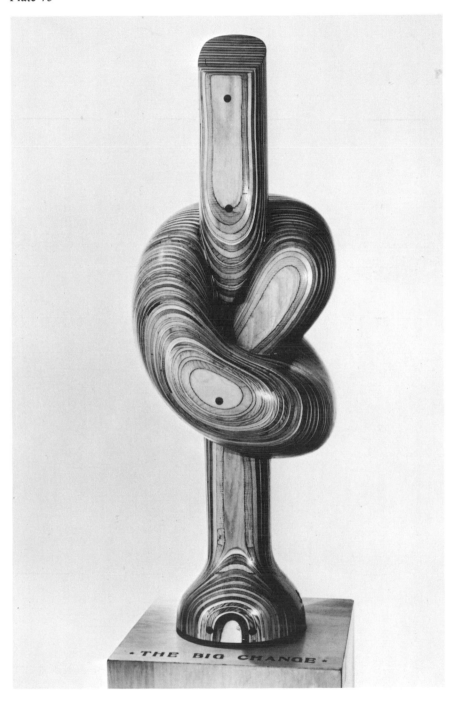

H. C. WESTERMANN: *The Big Change* (1963). New York, Mr. and Mrs. William Copley.

Plate 76

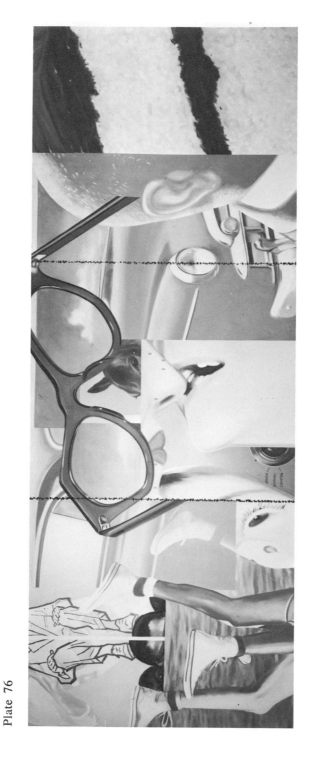

JAMES ROSENQUIST: *Painting for the American Negro* (1962–63). Ottawa, The National Gallery of Canada.

Plate 77

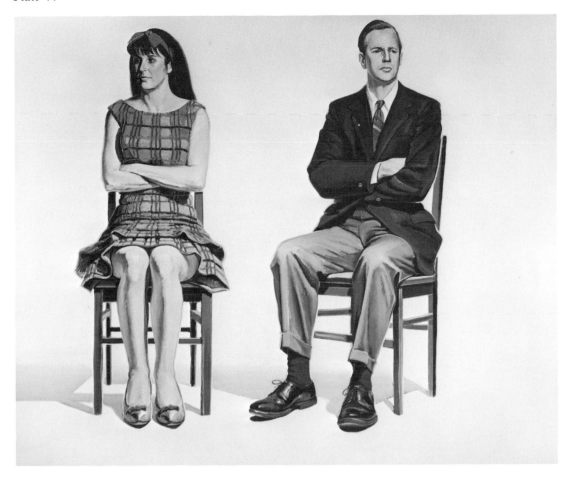

WAYNE THIEBAUD: *Two Sitting Figures* (1965). Collection of the artist.

Plate 78

PETER SAUL: *Ice Box No. 6* (1963). Chicago, Mr. Lewis Manilow.

Plate 79

TOM WESSELMANN: *Still Life No. 34* (1963). Kansas City, Mr. Jack W. Glenn.

Plate 80

ELLSWORTH KELLY: *Blue on White* (1961). Washington, Smithsonian Institution.

Plate 81

KENNETH NOLAND: *Drive* (1964). St. Louis, City Art Museum.

Plate 82

MORRIS LOUIS: *Moving In* (1962). New York, Mr. André
Emmerich.

Plate 83

GEORGE ORTMAN: *Landmark* (1962). Courtesy of Howard Wise Gallery, New York.

Plate 84

AD REINHARDT: *Abstract Painting No. 4* (1961). Washington, Smithsonian Institution.

Plate 85

JULIAN STANCZAK: *Gossip* (1964). Courtesy of Martha Jackson Gallery, New York.

Plate 86

JERRY FOYSTER: *Plastic Animation* (1964). Dallas, Mr. Henry S. Miller.

Plate 87

TADASKY: *Untitled* (1964). Courtesy of Samuel M. Kootz Gallery, New York.

Plate 88

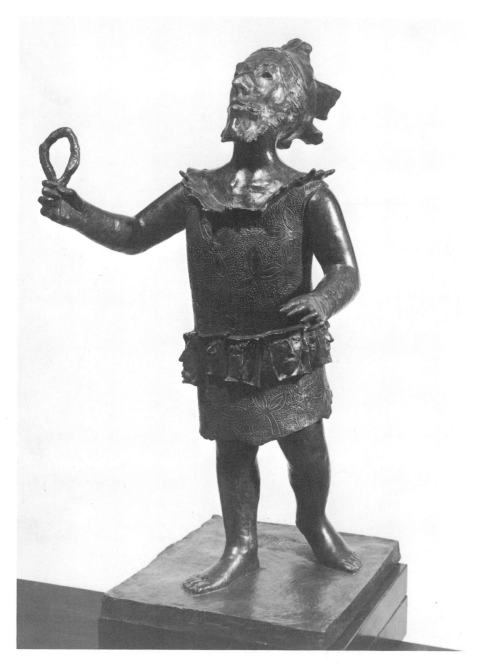

DAVID ARONSON: *High Priest* (1964). Courtesy of Nordness Gallery, New York.

Plate 89

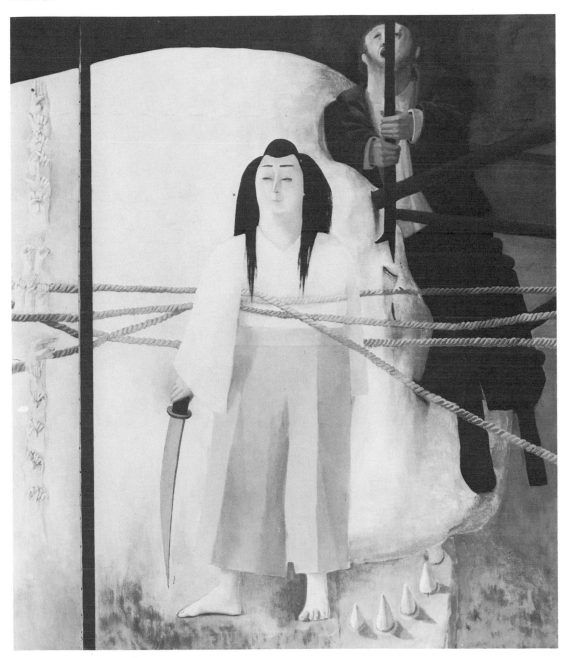

MORRIS BRODERSON: *Battle of the Giants* (1964). Los Angeles, Mrs. Don Quine.

Plate 90

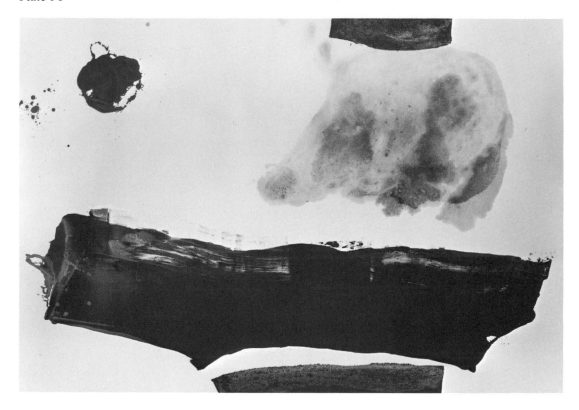

MASATOYO KISHI: *Opus 62–607* (1962). Urbana, Illinois, Mr. and Mrs. Allen S. Weller.

Plate 91

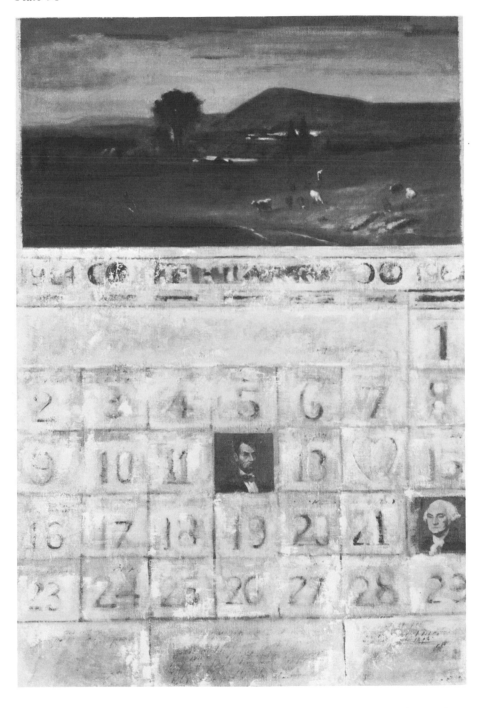

GEORGE DEEM: *February 1964* (1964). Courtesy of Allan Stone Gallery, New York.

Plate 92

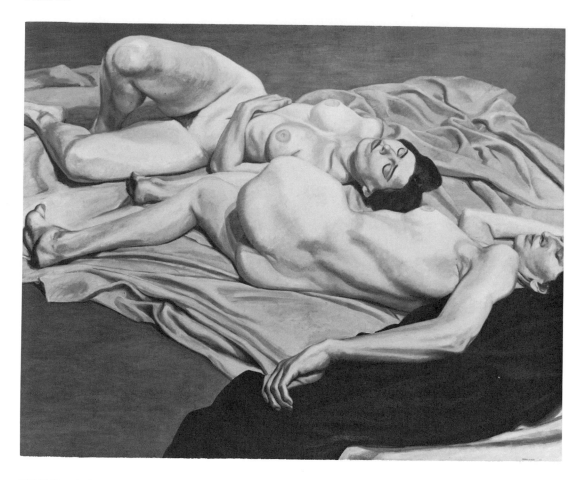

PHILIP PEARLSTEIN: *Two Reclining Models* (1964). Courtesy of Allan Frumkin Gallery, New York and Chicago.

Index

183